PRACTICAL LETTER BOOK

J. H. Kaemmerer

DOVER PUBLICATIONS, INC.
Mineola, New York

Bibliographical Note

Practical Letter Book, first published by Dover Publications, Inc., in 2016, is a reprint of the edition originally published as *Kaemmerer's Practical Letter Book: Containing Several Hundred Alphabets in 140 Plates; Together with Descriptive Text, For the Use of Sign Painters, Show Card Writers, Decorators, Artists and Craftsmen.* By J. H. Kaemmerer, Edited by Arthur Seymour Jennings by The Trade Papers Publishing Company, Ltd., London, in 1911.

International Standard Book Number

ISBN-13: 978-0-486-80676-1
ISBN-10: 0-486-80676-6

Manufactured in the United States by RR Donnelley
80676601 2016
www.doverpublications.com

INTRODUCTION.

ALTHOUGH there are many books of letters published for the use of sign painters, artists, architects and others, yet there appears to be ample room for one which gives a large variety of different shaped letters based on a proper plan of proportion and all having the merit of being simple in form and easily read.

The present work is intended not only for the use of students but also for professional sign writers, who should be able to find herein a letter suitable for any purpose. The author can claim that every letter is a thoroughly practical one, and the absence of superfluous ornament is a feature of his letters which he has taken great pains to draw. Special attention has been given to spacing although it will be understood that no fixed rule can be laid down on this subject as so much depends on the particular letters which are adjacent and other circumstances.

SERIES 1.

ENGLISH BLOCK LETTER.

In order that a word may be symmetrical and easily read, it is necessary that the letters should be well proportioned and quite carefully spaced. The English block letter is to be commended on account of its clearness and also because of its simplicity. The art of forming letters is easily acquired, and these forms are developed later into others more difficult to paint.

On plate 1 is shown the typical English letter which it will be seen by the small squares that the proportion is 3 broad and 5 high, thus giving an oblong shape. The squares answer also the purpose in giving the proportions of all of the letters, and the reader will observe that there will be no difficulty in increasing or decreasing the size according to requirements. Of course, these proportions may be varied according to desire, as for example, if the width is taken at 4 and the height maintained at 5 as on plate 3 a very neat and serviceable letter is produced. The proportion of 5 to 6 as shown in the third line from the top in plate 3 and of 5 to 5 as shown at the bottom line giving equally satisfactory letters.

It will be seen that some of the corners are rounded off, but the reader is warned that if this rounding was applied to the letters proportioned as on plate 1 the result would not be satisfactory, as those letters are too narrow for the purpose. The M. W. and Y. should be one-third wider than the other letters, the distance between the letters is also one-third. These proportions however are by no means arbitrary but must be varied according to the particular word that is being painted. A case where a variation is very necessary is where a sign is to be placed at an elevation and is to be viewed from the ground, for instance, if it is even 10 ft. high it might be necessary to slightly thicken the top and bottom portions of the letter so as to allow for the shortening which comes about from viewing the letters at an angle.

Plate 4 shows a number of different proportioned letters and will indicate the very considerable variation which can be made with the English block letter without destroying its characteristic form or legibility. The centre part of the English block letter, as in the B, H, E, R and S, should not be exactly in the centre, from top to bottom, but a little higher, which gives a smarter appearance. The reader should compare the letters E, H, R at the foot of plate 1 with the first letters F and B on plate 2, also the letters R, K and A at the foot of plate 1 and the third letter X on plate 2a, comparing with those of the first alphabet on plate 1.

With regard to the letters R, K, they are better constructed than the A, on account of its broad bottom occupying more space. The underlining letters S, M, K, N, I, J and C, at the top of plate 2, are all faulty and are given in order that those faults may be pointed out. If these letters are compared with those on plate 1, the faults will be at once apparent. The openings of the letter S, for instance, are similar in size, and this causes it to lose its smart appearance. The heads of the letter M are too narrow. There is too great a gap in the centre and this can be avoided by attaching each slanting part against the erect letter leg, by which means the head will become twice, or at least 1½ times, the width. The same principle applies to the letter N, which is too narrow. The K indicated on this plate does not really belong to the English block letters at all. In the letter C the two curved portions are equal, but this does not give so correct a shape as the other shown in plate 1. The letter Z, also with its sharp top and bottom, is not strictly in accordance with English block letters.

Referring again to plate 2, in the second row will be found a row of letters with vertical lines. These are intended to indicate that these particular letters should not be placed closer to each other than the vertical lines; for example, the T, if placed farther to the left toward the L, would be incorrect. The same rule applies when a slanting letter is placed next to a straight one, and even more so when a slanting letter appears next to a letter with rounded corners. If you wish to increase the distance between letters having slanting legs as A, V, A, W, etc., this can be done, but the proportion must be maintained. The letter L always presents more or less of a gap, and this is accentuated when it happens to come between two slanting letters or one slanting or one straight. To prevent this gap, the L should be made somewhat narrower than the other letters.

In the next example it will be seen that, having made L a little narrower, the letters appear on both sides as close together or as near as possible to it. If A appears on the open side of the L, then the D, or other straight rising letter standing in front of it may be placed a little farther away from the L than the distance already fixed. This, however, is not necessary when the letters V or T appear on the open side of the L.

Referring to plates 3 and 4, it is intended to show that the same letter type and with one colour only, sufficient variation can be obtained by slightly altering the shape of the figures. Plate 4 shows a series of similar altered types. The monotony of a big inscription can also be broken up by not making the heads of all the letters square, although nearly every plate in the first series contains letters of various shapes and sizes, and plate 3 may well serve as a model.

If the sharp corners of the English block letters are omitted a fuller form is obtained; the round head also gives a good effect when placed opposite other forms, although it is in itself perhaps not so elegant. The letters E, L, T, J, on the right hand of the 4th row of plate 5, have it will be seen, a slight protruding sharp corner, but this gives the letter the appearance of belonging to another type altogether.

Thus far we have discussed capital letters only. It will be understood that it is not necessary to place after each a fullstop, or to use at the beginning of each sentence a bigger initial letter, at the same time, when a large inscription is written, the introduction of a few stops facilitates the reading. It need hardly be said here that a period or fullstop invariably follows an abbreviation, such as Thos., an abbreviation for Thomas, but it is not at all necessary to have a comma at the end of each line although its use is by no means incorrect.

As a rule capital letters are much larger than those following, and are arranged so that the lower portions are in a line. Occasionally the top is painted level with the tops of the other letters so that the bottom of the capital letter projects. If this is done, great care must be taken to make the capital letter at least one half the size bigger than the space or the impression will be given that a mistake has been made. Frequently the large initial letter is placed so that the middle of it coincides with the middle of the smaller letters which, of course, means that the top and bottom both project a little beyond the other letters. Several variations are shown in the bottom line of plate 5.

In plate 6 is shown a small or lower-case English block letter. These as a rule are not used by painters to the same extent as the capital letters, but they can be very easily painted, because they are like the capitals square. It will be observed that the uniformity of the capital letter has entirely vanished. These lower-case letters are very useful when there is sufficient space available for the purpose and particularly where there is only one line, so that plenty of room is left for those letters such as f, g, which come beneath the line. Letters c, i, o, s, v, w and z, which appear among the small letters have exactly the same shape as a capital letter, hence they are sometimes called "small capitals," but the term is misleading.

We come now to consider the relative size of the small letters as compared with the capitals. The plates give perhaps sufficient indication of the difference in size, but the following remarks may prove useful. Having once fixed the size of the capital letter we have a basis upon which to work. The safest plan however, is to start, first, with the division of the small letters according to the space they are to fill, and then to fit the size of the principal or capital letter accordingly. In plate 1 it will be remembered we took the proportion of the capital letters 5 high and 3 broad. If we reduce the depth by one fifth and the width by one third we obtain the size of the small letters 4 by 2. On the left hand top corner of plate 6 will be found a capital letter L with a small a set in. This serves as an illustration of the relative sizes

and both together constitute the entire surface of the capital letter. As is shown here 4/5ths of the depth of a capital letter L is the depth of a small letter, and 2/3rds of the width of the capital L is the width of the small letter. The same proportion has been followed in the case of i, d, below, but it will be seen here that the 5th part in depth is taken up by the projection of the D; it will thus be seen that having fixed the size of the capital letter, it is a simple matter to obtain the proportion also of the small letter, and any variation can be made of this, as for example, the bottom of the L might be wider in which case the 2/3rds giving the width of the a would, of course, be correspondingly wider. The letters f, j, r, and t, are all similar in width but narrower than the other letters of the alphabet. The t is made a little shorter than the capital letters. The width of the above-named four letters should be made equal to 2/3rds that of the others, or 1/3rd narrower than the other letters.

The line drawing of the smaller letter N which appears on plate 6, illustrates more distinctly the curved part of the letters, and gives the centre in which a circle might be supposed to be drawn for the top and inner curves respectively. It must be remembered that although the above scales and proportions are admirable, as a rule they cannot always be strictly adhered to. Other scales of proportions are shown on plates 6 and 7.

At the right of page 7 small letters are given. These belong to the series having sharp protruding corners, a style of letter which has already been mentioned. Capital H and Capital I will also be noticed. The two lines of the bottom appearing on the same plate will be referred to later. The figures or numerals belonging to the English block letters will be found at the top of plate 85.

SPACING THE LETTERS.

We come now to a consideration of the divisions or spacing of the letters. The first question the student will ask himself is this: " How can I arrange so that the finished word will be precisely in the centre of the

space which it is to occupy?" If the word does not contain the letters I, M or W, the division does not offer any difficulty. Count the number of letters contained in the word; if there is an even number the middle letter should of course be placed in the centre of the board, and the other letters added a similar distance to the right and to the left. For example, in the word "Decorator," the R would be painted first in the middle and should then proceed a, t, o, r, and then paint o, c, e, d, to the left. If the word contains even number of letters a space will occur at the middle, and half of the entire word placed on either side, working again from the centre as before. Should however the letters I, M or W, occur in either of the above examples, then the additional or lesser space which would be required for these letters should be divided in half, and with this size as a basis the letters should be moved to the right or to the left.

There are many rules which can be used to obtain a correct spacing, as for example, the total length of the line could be measured and this divided by the number of letters which will give, of course, the space for each letter, plus an allowance for spacing, but as a rule, the practical sign writer takes a piece of chalk and roughs out the lettering, working from the centre, and is able to space without difficulty. This is largely a matter of practice and the student cannot do better than constantly write words so as to get into the habit of spacing correctly. This he can do if even he is not very expert in painting the actual forms of the letters accurately. At the commencement it may be well to roughly indicate the position of the various letters by means of dots but the chalk method is perhaps the best.

RAISED LETTERS.

Formerly this style of lettering was very much in vogue and it is often used to-day. Many sign painters, even those of some experience, find it very difficult to get the correct shapes, and we therefore give some precise instructions on the subject, taking first, by way of example, the letter I, as shown in plate 8. We will imagine that the letter is solid and made of wood, that it has a thickness as well as a depth and breadth. It is supposed that the letters are arranged in such a way that the sides can be viewed as well as the front. The proportions shown on plate 8 need not be strictly adhered to. In plates 83 and 84 these are shown in exaggerated proportions. As a rule this class of letter is painted in two colours, the ground of course is another colour in addition. The bottom edge is usually darker than the upright edges. The idea, of course, in this class of letter is to give the impression of painting on a flat surface so that the letters are solid and stand out from the facia. This cannot be done unless a perspective is taken from the centre of the facia or top, and this can rarely be done.

A careful study of plate 8 will give the form of letters to be used according to the position it is viewed from. It will be seen that if "I" is below the letter of course the bottom surface will show, yet on the other hand, if the "I" is above the letter the bottom will show, and this will be quite clear on referring to plate 8.

SHADING OF THE LETTERS.

A raised letter may be painted with good effect and two or three examples are shown on plate 9. The idea, of course, is to increase the raised effect. The shading is generally introduced on that side of the letter which is not raised, excepting at the foot where it runs along the raised portion (see the letter B in plate 9). The shading is indicated on plates 10 and 11. In some cases it is necessary to make the shading run upwards, as for example, when the letters are at a higher altitude than the light illuminating them, as for instance, in the letter D. In this case the under sides of the letters also should be of a lighter colour than the erect ones. In plates 9 and 10 the ground surface or base of the blocks have been partly indicated by dotted lines, the front surface by ordinary lines. It will be noticed that the shading on the under side of the blocks is broader

than that of the upright sides. This is done because a portion of the shadow on the upright space is, so to speak, covered by the block itself. It may be mentioned here that the science of shadow projection is part of the study of solid geometry, and a very interesting one. Space will not permit of us going into the subject at greater length, but for a small sum a manual on "Shadow Projection" can be purchased, and we advise our readers to buy one and study it very carefully.

As to the additional plates in this series, little need be said. The English block letter has been painted in every conceivable position and variety, and as far as the letter permits of decoration this has been included. Raised letters in various forms are shown on plate 13, on plate 14 there is a wide variety of lettering, shaded and otherwise, and plate 15 the word "Schilder" is shown in a very attractive form of shadows, and this would form an admirable copy of students, while the raised letter in "Finan" and the inscribed letter in "Cieel" would also be good practice. The same is true with the word "Kon," which represents those letters cut out of wood. It will be observed that the incised part is represented by a dark line, which in turn throws a shadow on the surface beneath. To accentuate the effect a little white is added on the opposite side so as to apparently bring this surface to the front. As before noted raised block letters may be used in a large variety of styles. The word "Zomer and Winter" on plate 16 will please many and the word "Herfst" on the same plate is one which again is well worthy of the student's careful study. Plate 18 is in itself a capital study of the effects of shadows set up by letters of peculiar form. It will be observed that each one is bent and that the shadow takes a corresponding form although it is of course reversed. Plate 19 is a similar letter but bent the reverse way.

Plate 20 shows the introduction of ornamentation on the face of the letter, while plates 21, 22 and 23 gives various suggestions for signs, and although they are not English, of course the form of the latters and not the words is what the painter wants. There are many possibilities which these plates will suggest, as for example, in the word "Bordeaux" as well as in "Bodego," "Oporto"; indeed, there is practically no limit to the form of these letters, and these particular plates may be shaded again and again to get novel effects.

SERIES 2.

DUTCH BLOCK LETTER.

The form of this letter, although really more precise in its division and execution than the English block letter, yet it possesses the advantage of being distinctly readable. The plates show many different types of this letter which need not be discussed separately, but the reader is advised to compare one with the other very carefully, when he will see their advantages. As in the case of the English block letters this variety of lettering may be produced in nearly any size or proportion. The down strokes may be thicker than the up strokes, or both may be of the same thickness, according to one's taste. The serifs or projecting parts of the letters can be varied according to choice and they may either be made square or rounded off. Again the lower portions may be made heavier than the upper portions if desired, and these parts may be extended if wished as in plate 27. An example of the heavier serifs at the bottom is shown on plate 25 in the word "Berlin" at the bottom right hand corner. The latter is particularly suitable where space is very limited, as the form of letter may be used in spaces which would be practicable with any other letter type without infringing upon the legibility. It will be noted that the thick portions of the letters at the top and bottom divide up the space, the stems of the letters, so to speak, may be very thin if required, as shown at the top right hand corner of plate 25 in the letters I, C, E, B and H.

Various forms of the Dutch letter are shown on plates 24, 25, 26, 27, 28, 29, and it should be mentioned here that this form of letter is based on the Roman. On the last named plate are given some slightly ornamented forms of this style of lettering.

SERIES 3.
ROMAN LETTERS.

The letters of the first alphabet shown on plate 30 are shown slanting, and are frequently used with capital and small letters following. The italic character is introduced as a variation. It dates back to the 15th century, and was invented by Aldus Manutrus of Venice in 1498. It is very useful indeed for large signs, in breaking the monotony. The letters appearing below are exactly similar, excepting that they are upright instead of being slanting. This Roman letter is very common, being used in most European countries for the printing of books and newspapers. In shape they resemble very much the Latin type. If a comparison is made between the small letters at the bottom of plate 30 with those at the top of plate 6, the difference will be seen; as a matter of fact, the name " Roman " letter is frequently given to both, although incorrectly. The Roman letter is a well proportioned one, on account of its thin up strokes and thick down strokes. It is neat and easily read, and permits of a good division of spacing. It is necessary, however, to take care that the thin up strokes are always in harmony with the heavier parts of the letters. Naturally the larger the letter, the thicker will be the up strokes. There is no limit to the size of these letters, and the proportions may be varied as one wishes, although it is well not to exaggerate this particular letter too much, that is to say, not to have too great a depth in proportion to the breadth, or *vice versa*. If this is done the letter loses its character.

In cases where space is cramped or extended, it is much better to choose another type of letter altogether. The small capital letters are very rarely used by the sign painter, on account of their unequal sizes, neither are they so legible. In any case, at the beginning of each sentence it is necessary to use a capital or initial letter, and those letters following should be written smaller. But the fact that some of the letters drop below the line, such as J, P, G, Q and Y, renders this particular style of letter in the lower case unsuitable for many positions. If, however, no letter in a word descends below the line, then the style of lettering is a good one. Every sign painter should certainly consider it his duty to make himself competent in writing this particular style of letter, if only for the reason that it is used so very largely in book and newspaper printing.

On plate 32 will be found the Roman letter depicted as being raised, and on the same plate will be found examples of the manner in which the letter is extended. Plate 33 gives some condensed lettering in this kind, and one or two other styles.

The author suggests that the form of lettering shown at the top line of plate 34 might sometimes be adopted. It will be seen that the letters are so formed, as to bring them all within the same parallel lines. Plate 34 contains fancy capital or initial based on the Roman, which, provided they are painted in a different colour from the rest, may not only be used in conjunction with the Roman, but also with other types of letters.

SERIES 4.
FRENCH LETTERS.

None of the six plates in this series requires any particular description. The style is an elegant and useful one. The letters on the lower half of plate 35 are clear and graceful. This is a shape which is

much used by wood carvers and stone masons. It will be noticed that there are throughout sharp points to this letter. Plate 36 gives a French letter which is very useful to the stone carver, but it may be of course imitated by the painter without difficulty on a marbled surface. Plate 37 gives a French letter somewhat varied from the usual form. With the exception of the lower portion of plate 40, the points of this letter are always sharp.

SERIES 5.

WRITING OR SCRIPT LETTERS.

To beginners this is perhaps one of the most difficult letters to paint. They do not possess a strictly uniform shape, but there are certain rules which must be followed. In other words, if they are not drawn freely and exactly slanting at the same angle, the effect is very bad. A great deal of practice is necessary to produce the correct shape, and the following hints will be useful.

The script letter looks best when, in addition to a slender shape with fine but distinct up strokes, the down strokes are also fine. In this style of lettering, one must be what is technically known as "brush steady," although, of course, it is practically hand writing on a large scale, yet it requires, as already stated, a great deal of practice however good a writer one may be. The possession of the talent to write this letter properly is a valuable asset to the journeyman sign painter, and practising this style of letter enables one to gain a mastery over the brush which is exceedingly useful when painting in other styles of lettering. As far as the writing is concerned, it is well at the start to make these invariably oval or based

upon the oval as indicated on the second line of plate 42. The various strokes, thick and thin which the beginner should assiduously practise are shown on the top line. The general style of writing is shown below, and it will be noticed that this is made slanting rather more than usual, the idea is to separate the letters, and to acquire the habit of slanting considerably. If the reader can manage to copy plate 42 accurately, he will have no difficulty with any of the other script letters. If flourishes are introduced, as in plate 41, they must be all of exactly the same character, and a study of this plate will show exactly what is meant by this. The same character pervades every letter shown on this plate. Note particularly the letters A, B, M, N and R. Compare M and N and the R with the B, also note the end flourishes of V, W and R; the W is introduced rather differently, only by way of variation, as a rule the flourish would be exactly the same as the V or the K.

If the reader will now turn to plate 43, he will see what is meant by the expression that lettering in this stage should be "of the same family." It is always advisable in lettering, that the style adopted be adhered to throughout as far as possible, but to reiterate, in script it is absolutely essential. In plate 43 the letters are all exactly the same order. It is a very pretty letter, although with perhaps a little too much flourish to suit many people. The rule already referred to, as to the importance of keeping letters uniform in style, is shown also on plate 76 and plate 124.

These script or writing letters can be handled in various ways, as shown on plate 44. They may be thickened at the top and bottom, or at the bottom only, as shown on the same plate. It may be noted here, that many of the ornamentations shown in the English block letter can, if desired, be adapted to these script letters.

A few additional hints may be given having reference to plate 45 which is of particular interest to the student and concerns the proportions of the letter and degree of slant. In order to restrict as little as possible the desired freedom when writing these letters we will only deal with the most

important parts. A good angle for slanting is 45° but some prefer that the slant shall be more upright, say 60°; this is purely a matter of taste. As to the width of the letters, with the exception of M and W, the size will not be the same; take for example, O and A. The O will be the same as the A as far as the oval is concerned, but of course the A will have the advantage of a down stroke. The same is true with the D and G shown in plate 45. O and E should be the same as the oval portion of the D and the G.

SERIES 6.
VARIOUS EXAMPLES.

The letters in this series are of various shapes and many of them very old types. They are perhaps as valuable as any in the book and will be useful for the sign painter who wants up-to-date letters although they are really very old forms. It will be observed that the proportions are not well maintained. The type shown in plate 46 is a very useful one, graceful in shape and a great favourite among architects. At the foot of plate 47 the same type of letter is shown in lower case; this makes an artistic sign and a very readable one. On plate 48 at the top is an old letter type dating back to the year 1657. This is followed by an alphabet of old decorative letters from the year 1700, and at the bottom are a few rather pretty decorated letters of equally ancient date. The reader should turn also to the second row of letters on plate 73.

On plate 49 we have similar letters to those on plate 48, but in a slanting position and decorated in a different way. These letters may at first sight appear to be a little strange, but there is really something attractive about them and they would show up much better if they were represented with suitable surroundings. The same remark applies to slanting letters at the foot of plate 49, and also to the ancient letters shown on plate 50. The shapes on plate 50 and 51 are a little removed from Roman and are very useful in many trades and in a large number of different positions.

SERIES 7.
GOTHIC LETTERS.

These letters are very ancient, especially that on plate 53. They date back as far as the year 1500. It is obvious that for general use they are quite unsuitable, yet in exceptional cases they may be of considerable utility; for example in a Gothic church or other buildings of an ecclesiastical character they would be very appropriate. Frequently they are used as initial letters followed by a small German or other old letter type, especially when they are gilded or painted in a red and black inscription. The letters shown on plates 55 and 56 come nearer perhaps to the modern requirements, but there is sufficient variety in these few plates to give the reader every style which he is likely to be called upon to produce.

SERIES 8.
GERMAN LETTERS.

Although there are not a very great variety of letters shown in these plates, yet those which have been selected possess the merit of being popular, because they are comparatively easy to read. The shape of the German letters may be considered both handsome and graceful, although one is not called upon very frequently to write them, yet they are useful

to them on occasion, as for example, what we know as Church Text is frequently based on the German. It is important to remember that a capital letter must not only be used in German text at the beginning of a sentence but also for every noun that occurs. German letters are excellent as capitals or initial letters to Roman or other types. They may be decorated or varied in form as shown on plate 64. Plates 57 and 58 contain the modern German printing and writing letters, and those following in this series various other forms likely to prove of service. Plate 62 gives forms which although based on the German will be found very useful in all sorts of work, in fact some of these letters might be taken as a base upon which to work out the whole alphabet.

SERIES 9.

ROUND HAND SCRIPT.

Round script or round hand writing, as it is sometimes called, practically speaking, is done in writing by means of a broad pen, and there are pens on the market which have several nibs joined together whereby a letter may be formed consisting of two or more strokes with a wide space between. It is rarely used in connection with other letters, being a style of its own, but on occasion is very useful. It is useless to endeavour to make up a sign of capital letters only in this style; it is quite essential that the small letters be used in conjunction with capitals introduced at the proper place. For lettering on glass this style is not infrequently employed, and they are useful for shops. The types are shown on plates 65 and 66 with variations at the bottom of the letter. The reader who desired to acquire this style is advised to take a very broad pen and to rule lines so as to obtain

the exact size of the letters and to practice for a few weeks, when he will find he will become very expert. It will be observed that the heavy strokes are shown upright on the plate. Frequently however they are slightly inclined from left to right, so as to fall backwards, so to speak. Most stationers keep the pens referred to and sell them as engrossing pens, this style being used sometimes for engrossing, although old English is more frequently employed. Plate 67 gives the same style of lettering but thickened; this is sometimes used for lettering on glass or for a facia. The style of lettering shown on plates 68, 69 and 70 will be most liked by many because of their slope, but as stated the slope the other way is the correct form. The numerals or figures appertaining to the letters on plate 70 will be found on plate 88. Plate 71 shows a further variation of this form. As far as the writer knows this particular style has never been published before.

SERIES 10.

MISCELLANEOUS LETTERS.

These different styles will serve as a valuable guide to those who are fairly proficient as sign painters. They show a large variety of different letters and indicate sufficient to enable the expert sign writer to carry out a whole alphabet or to write any word in the style suggested. As for example, on plate 72 there are shown 8 different styles of letters, any one of which might be adopted according to one's taste. For instance, the word "Timothens" would be liked by many, it being a very elegant letter which

can be used with good effect on many occasions, and the same is true with plate 73, where the word "Nederlands" could be used effectively although the letters might be of the same size. The white line around them with the shading gives a very pleasing result. The word "Sohuki" gives a very good example of shading of raised letters, as do also the letters on the bottom line but one of the same plate. On plate 74 are given three very attractive styles, the bottom one being a little difficult perhaps to draw, but most effective in its appearance. The second, third, fourth and fifth rows of plate 76 are recommended for those who require something out of the common, while plates 77, 78, 79, 80, 81 and 82 are all worth studying. The immediate object of letters in this series is to stimulate the student's mind and to give the professional sign painter many styles from which to choose.

Particular reference must be made to plates 83 and 84, which in themselves are very valuable, giving as they do various methods of handling an ordinary block letter very effectively. It will be noticed that each letter gives a different style, all of them decidedly handsome and all of course perfectly clear and legible. The H, E and the T on plate 83 and the E and H on plate 84 are believed to be types which can be used with very great advantage in many positions.

SERIES 11.

NUMERALS AND FIGURES.

The plates in this series, as indeed most of the others in the book, may be said in a measure to speak for themselves and only a very few directions for their painting are necessary. Among them will be found numerals suitable for going with all styles of letters. At the top of plate 90 are represented Roman figures as usually employed on watches, clocks and sundials. In this case it is necessary to place the figures as close together as possible in order to save space. If in painting a clock Roman figures are employed they must all radiate toward the centre. The same is true if ordinary figures are employed. Plate 91 gives a glimpse of figures of Ancient date and as a contrast there are shown on the same plate some of quite modern type. As already stated it is not deemed necessary to elaborate the description of these plates, they being sufficiently explicit by themselves.

SERIES 12.

MODERN AND OTHER LETTER TYPES.

With the exception of a few, the letters in this series would form a modern letter book by itself as there is so great a variety shown. In these days it is not a common practice to convert or transpose letters and frequently the governing rules are disregarded. It is hoped that the variety shown in this series will prove of very great advantage to sign painters and those who draw letters in general. It must always be remembered that legibility is of the utmost importance, although the painter may in his desire to obtain something new distort a letter entirely away from its original form, yet if he produces a signboard or a piece of writing which cannot easily be read, it must on that account be invariably condemned. This does not necessarily mean that the letters must be plain, heavy and crude. There are in this book many hundreds of different styles of an ornamental character,

yet styles which do not depend upon ornament which has been introduced merely for the sake of giving a pretty effect to the letter but ornamental in form, that is to say, that the original block or Roman letter has been adapted to produce something which is in itself ornamental and beautiful in form, and the letters are suitable for such a position as a motto in a hall or dining-room. It must not be forgotten that when painting modern letters such as those shown in this series, as a rule, relief letters and shading become superfluous. The outlines may be accentuated by an edging of colour, and there are other ways in which these letters may be dealt with where desired. We can only ask the reader to go carefully through the book and to study it again and again and very many possibilities will no doubt suggest themselves to him.

The plan of writing in white on a background as shown at top and bottom of plate 93 is one which on occasion is exceedingly useful. Even in plain letters as in the word Hudson a sign may be produced in a very short time. This is sometimes called "cutting in," and letters done this way can be painted very quickly. The word on this plate "Inrichting" is of course very fanciful, with the introduction of a small black spot on the N, to do away with the rather broad space at that point. It is artistic little touches like this which serve to greatly improve a sign, and a painter who is a man of his business need never hesitate to put them in provided that he does so in the proper place. The letters on plate 94 may be perhaps considered a little extravagant, but still there are several forms, and sometimes a client wishes an eccentric form of this character, and the same is true with the letters shown on plates 95, 96, 97 and 98. On plate 99 are letters of even greater eccentricity, and here again we have a style which would not please every one but might be exactly what some people would require. On plates 100 and 101 are two forms of letters with some originality, while those on plates 102, 103 and 104, are also useful on occasions.

The letters at the top of plate 105 are adopted from the French letter and may be used in some cases with very excellent effect. The same is true with the letters on plate 108. A good many different styles are shown on plate 113 and 114. A few purely ornamental letters ars introduced on plate 117.

SERIES 13.

FOREIGN AND OTHER LETTERS.

It may be thought at first sight that the average sign painter would have no use for foreign alphabets, excepting perhaps German. This however is not so. For example, he is called upon to do a sign for a German provision store or again a Jewish butcher. In such cases it would be valuable to him to have on hand the exact form of letters which he could correctly copy, hence this series. The author gives however only a few of those likely to be most useful. On plate 123 we have the German alphabet used as a printed letter and plate 124 German or Dutch writing letters or script; the same on plate 125. On plate 126 is given the Russian alphabet large and small letters and the same on plate 127. The Latin alphabet which is again like the French is given on plate 128; it is a fine style of lettering which is useful for many purposes. On plate 129 is given the Greek alphabet with the Latin name against each. This is continued on plate 130. The Hebrew alphabet is given on plates 131 and 132, the latter containing the small letters and the vowels. On plate 133 are shown respectively the Anglo-Saxon and Irish letters, while on plate 134 are the Greek, Old Greek, Old Gothic, Old Italian and Old Roman. The Malayan alphabet is given on plate 135 and the Assyrian on plate 136.

SERIES 14.

MONOGRAMS, VIGNETTES AND HANDS.

It would be an easy matter to elaborate the number of these pages to any extent but the reader might ask where it would all end. This book has already become sufficiently bulky to render it desirable to strictly limit the number of examples of monograms. These examples are given only to serve as a guide, and plates 137, 138 and 139 will be found useful for many purposes.

As regards the hands shown on plate 140, they can of course be transposed without any difficulty, that is to say, the hands which are shown pointing downways can be made with a very little ingenuity, to point upwards, and those which are shown pointing to the right can be painted indicating the left. It should be observed that the hands always serve their purpose best when painted in flat colours, and no attempt should be made to introduce more than the shading of white lines to indicate the parts of the hands.

It is well to observe in conclusion that the student in sign writing should recognise the necessity of practising at an early stage in his career the form of index figures or hands. Many a sign, excellent in other respects, has been spoiled by the inaccurate drawing of a hand. We did know a sign painter who was so poor at this part of his work that he invariably had a hand photographed in the position it was to occupy, and then traced it on his sign and painted it in. But one should not depend on such devices, but be in a position to paint a hand accurately at a moment's notice, so to speak.

As a final word, it may be said that it is hoped that the present book will be of service, and as already stated, not only to apprentices but also to master sign painters. It is intended as an incentive to emulate the work herein shown. The plates are not put forward as being perfect in every respect, neither is it suggested for a moment that any of the forms are novelties. The reader should remember the saying that "There is nothing new under the sun, neither is there in this world anything perfect."

PRACTICAL LETTER BOOK

PLATE 1

Series 1: ENGLISH BLOCK LETTERS

ABCDEFGHI

JKLMNOPQ

RSTUVWXIJ

Z,Y,&EHRKA

PLATE 2

FBXSMKNIJC
Z-LTLYFJTJVJLV
&TAVFAWJPAWA
PWOVCKJDAO
RYGXBLJTIFH

PLATE 3

ABCDEFG
AHIJKLVN
AMORS
ATUXYZ

PLATE 4

VEESTAPELS

LIMBURGSCHE FABRIEK VOOR VERSCHILLENDE :

INDUSTRIEELE

DOELEINDEN

ALMELOSCHE -
WEGWIJZERS

PLATE 5

EWILYJOVH

MANTEAUX

PAINTING

HATJU. VAT. ELTJ

HEDI & ILVJI & IFSE

PLATE 6

abcenz.abc

d MAISON

fr nocu

PLATE 7

Houtzagerij·khg:

lmnpqsvwxbfcdy

Huisknecht.abdflmov

Wxpijygrqza.

Houe

nfiy

acm

jgpq

rsw

bdhl

ktxz

PLATE 8

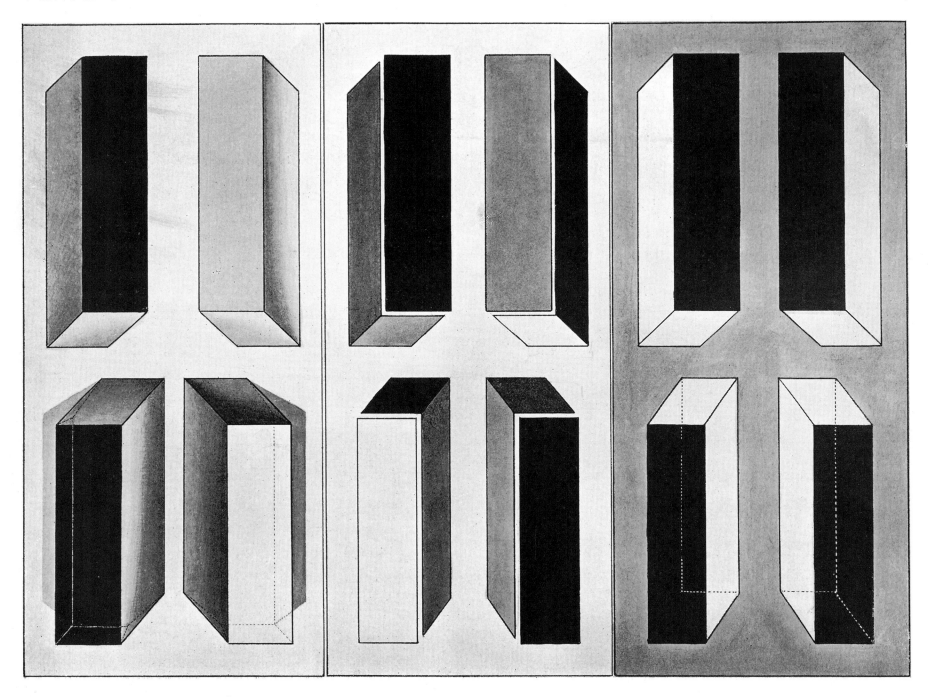

PLATE 9

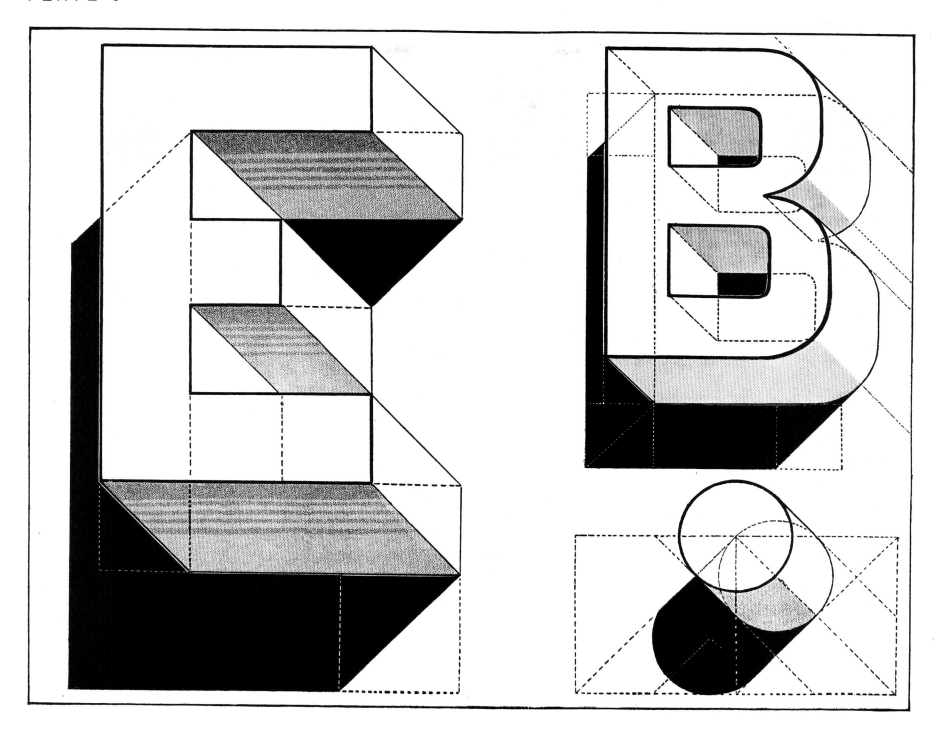

PLATE 10

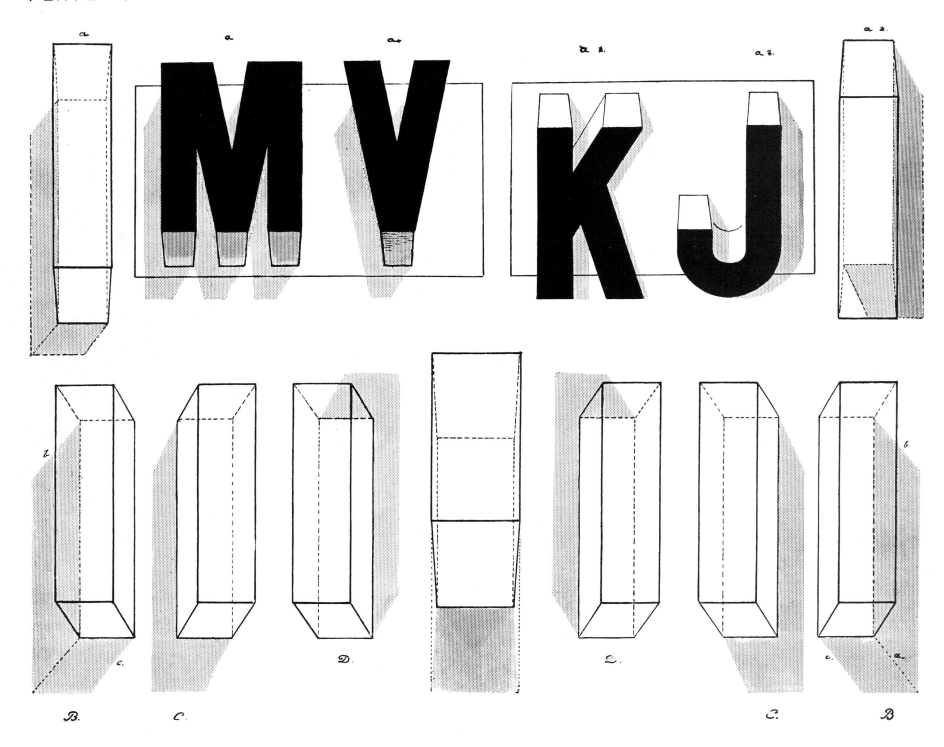

PLATE 11

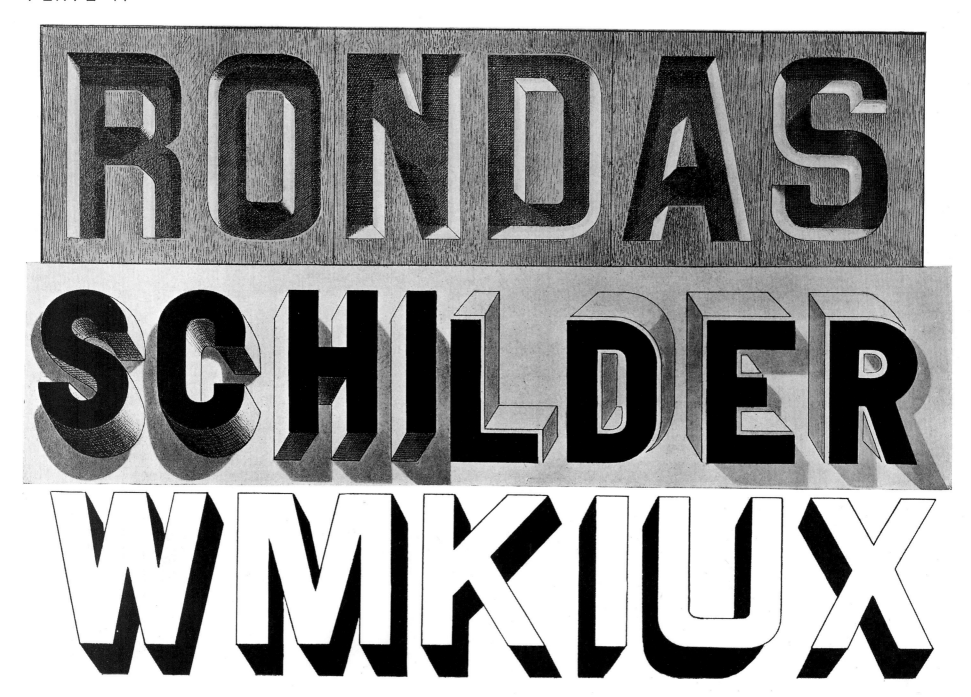

PLATE 12

DECORATIJMWB
EGHKNPSUVXZI
RECHTSKUNDIG
BOUWPLAN
LUCRETIA.

PLATE 13

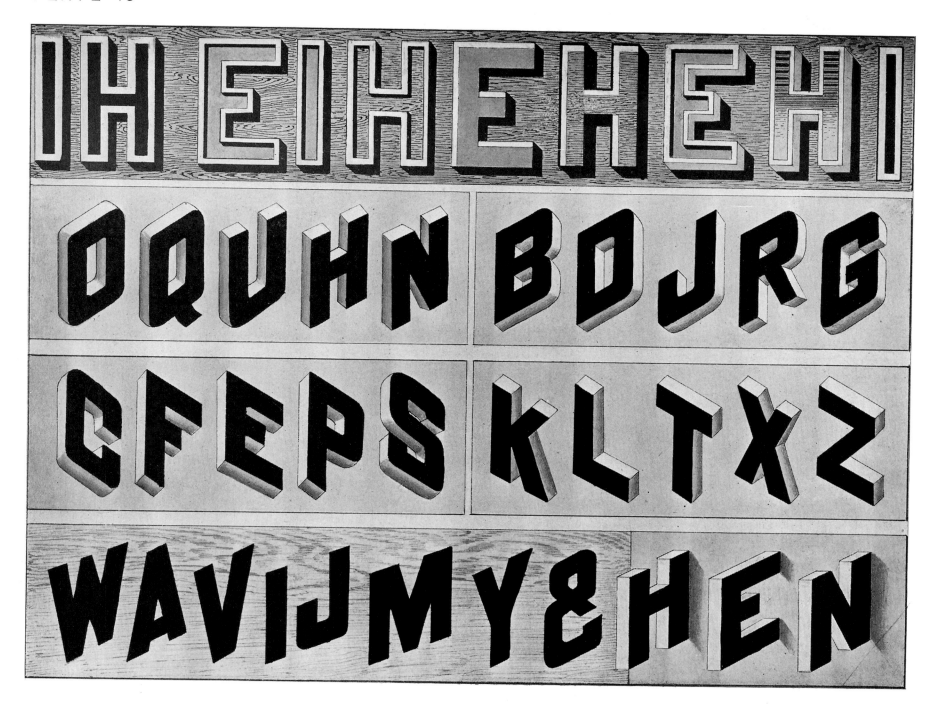

PLATE 14

TYPE EXTRA LT VJ HE UZI HE FA MIKW COURANT IJ TYPOGRAPHIQUE

PLATE 15

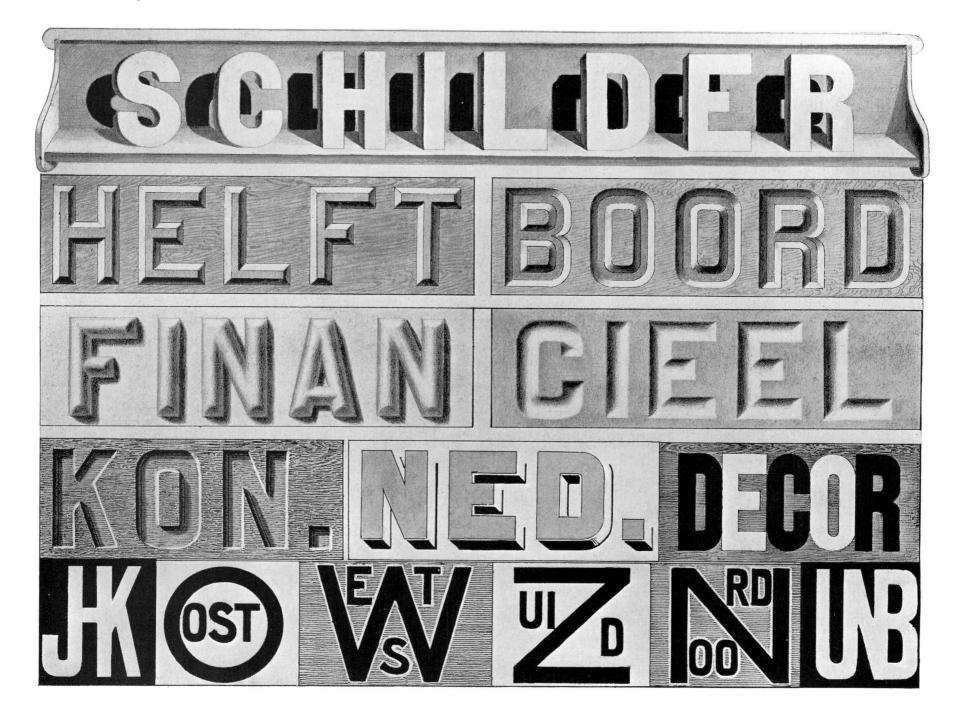

PLATE 16

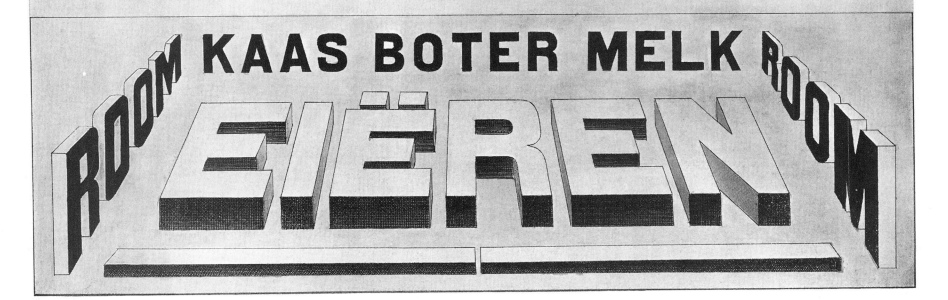

PLATE 17

ONDERWIJS
MARQUISE
MEXICOBFG
LTPVHKZ&Y.

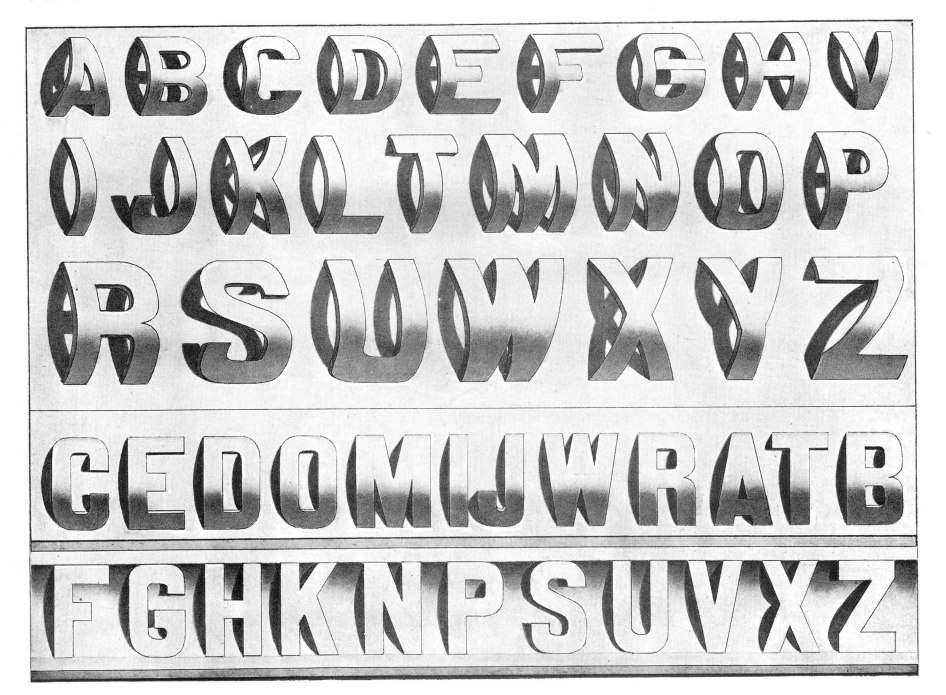

PLATE 19

ABCDEFFHGV
IJKLTNOMP
RSUWXYZ

CEDOMIJWRATB
FGHKNPSUVXZ

PLATE 20

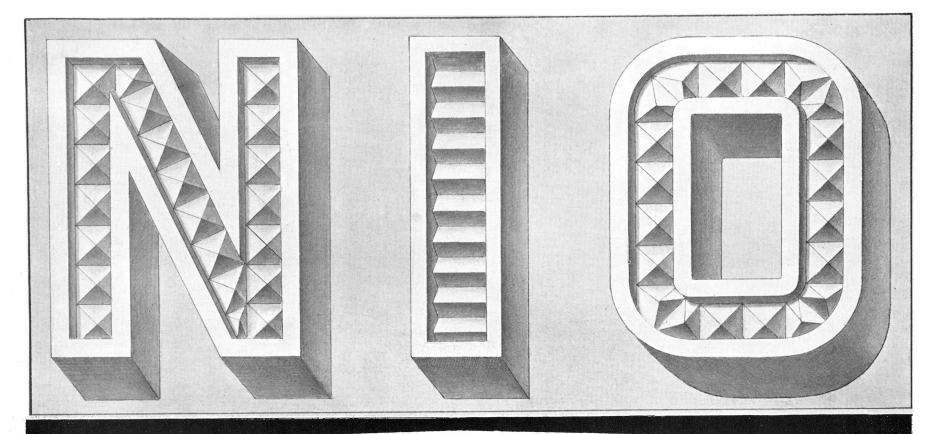

PLATE 21

FIJNE

BORDEAUX

18-8-?

BOEKDRUKKUNST

DRENTHE **DRESDEN**

BODEGA
22
OPORTO

DE GEKROONDE
W

PLATE 22

PLATE 23

EFFECTENKANTOOR ASSURANTIËN

TIJPOGRAPHIQUE

LEIDEN BIJKANTOOR ASSEN
ZWOLLE BIJKANTOOR GOUDA

SPIRITUSFABRIEK DE STER

NEDERLANDSCHE BANK

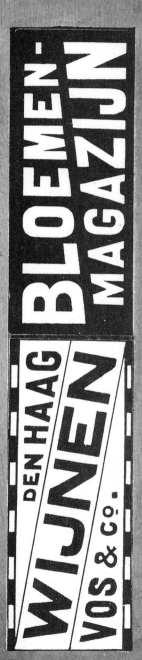

BLOEMEN-MAGAZIJN
DEN HAAG WIJNEN VOS & CO.

PLATE 24

Series 2: DUTCH BLOCK LETTERS

M.W.T. GRACIEUS & Zn.

PLH · BDN OVXY · KFJ

KUNST - ARBEID

ELIONMARS.

BCDFGHW JKTUVXYZ

VARO · MEIJRKST

BESCHUIT

PLATE 25

KUNSTBESCHOUWING ICEBH

Amerikaansch Touw. bdfltvz R

ABCDEFG | gJxpq | HIJKLM

NOPRTS & UVWXYZ

PARIS. PRIJSCOURANT berlion

PLATE 26

ABCDEFGH
IJKLMNOPI
RSTUVWXZ
Ykelhorstdal
bcfimnuvwx
Q g j z p q y &
1234567890

PLATE 27

STANLY.
GORKUM
BIZEFHIJ
CDPVWX
abdfthkoelc
mnrsuvwx
· ijg·pqz ·

PLATE 28

ABCDEFI
GHJKLM
QPRSTUV
ZWXY&

ABCDEFGH
IJKLMONP
RSTUVWX
YZ

PLATE 29

ABCDEFGHIJKLM
NOPRSTUVWZ
ABCDERKT
OLNGSUVZ.
NSP.ATC.ZBI
HERMA·NOICUS

ABCDEFGHIJKLMO

NPQRSTUVWXYZ

Cursief. finland. bchotk

gjmv x̱ p z̧ gy x̱ ʀ w q g

ABCDEFGHIJKLMN

OPQRSTUVWXYZ

abcdefhiklmnorstuvw-

x nro gjpqy vau z

PLATE 31

ABCDEFGI
HJKLMNW
OPRSTUVZ
XibdfhklteoY
acmjpgqy,srn
vw ——— uxz

PLATE 32

ABCDEM
OWIJT

HEMVJR
a·Loterij·z
uncsfvkb

PLATE 33

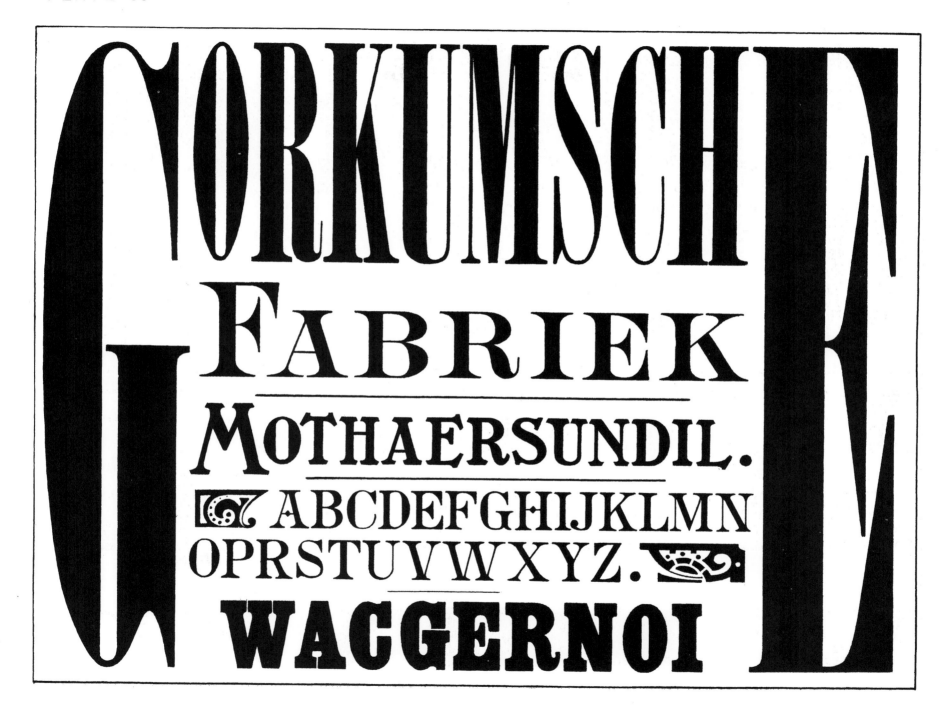

PLATE 34

Series 4: FRENCH LETTERS

abcdefghijklmnopqrstuvwz

ABCDFEG
HJKLMOPI
RSTUVWX
ZUID·NEW·YORK

PLATE 35

ABCDEFGHIJKLMNOP
QRSTUVWXYZ & bdfhl
ktaceimnorsuvwz‖gjpqy

ZYXWVUTSR
QPONMLJIH
KGFEDCBA.&

PLATE 36

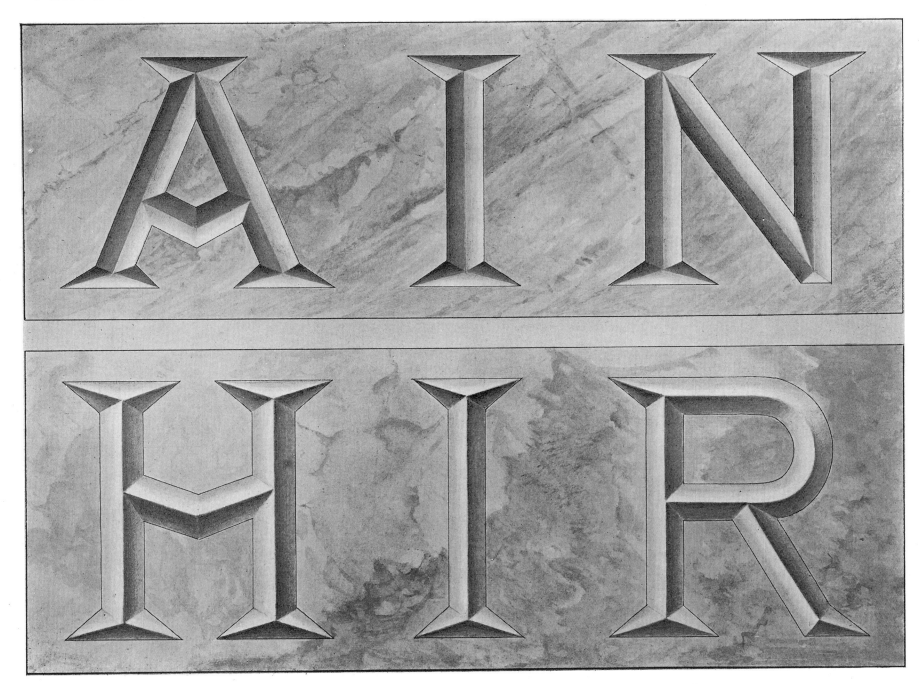

PLATE 37

ABCDEGIJLOP
FHKMNQWI
RSTUVXY&
Zilversmidbh
aenou f k t g y ij q p .
wxz

PLATE 38

HERMANUS.

BCDEFGIJKLOW

PQT&VXYZ

abcdefihmknlotr

suv g jpqy wxz

1234 5 6 7890

PLATE 39

PRIJSDAG.
VONK·E·T·B
Zalm — g d h — trein

MKRETGVJDN

ELDORAMYVICUST
Jiarufet. G. Z. T.

PLATE 40

ABCDEFGH
IJKLMNOW
PRSTUVXY
Z · &

ABCDEFGH
IJKLMNOP
RSTUVWX
Y & Z

PLATE 41

Series 5: SCRIPT LETTERS

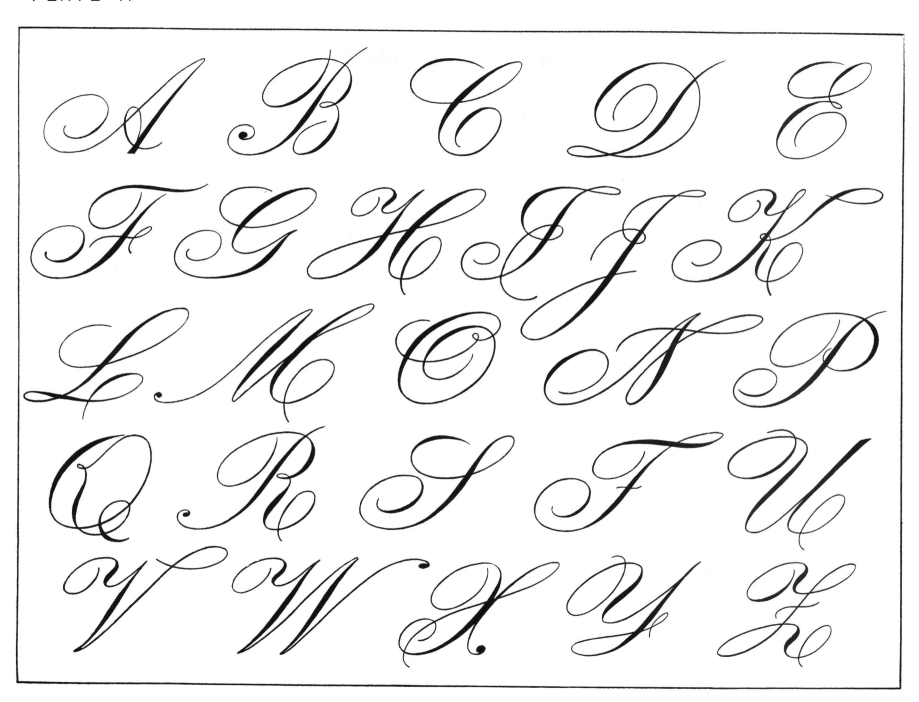

PLATE 42

PLATE 43

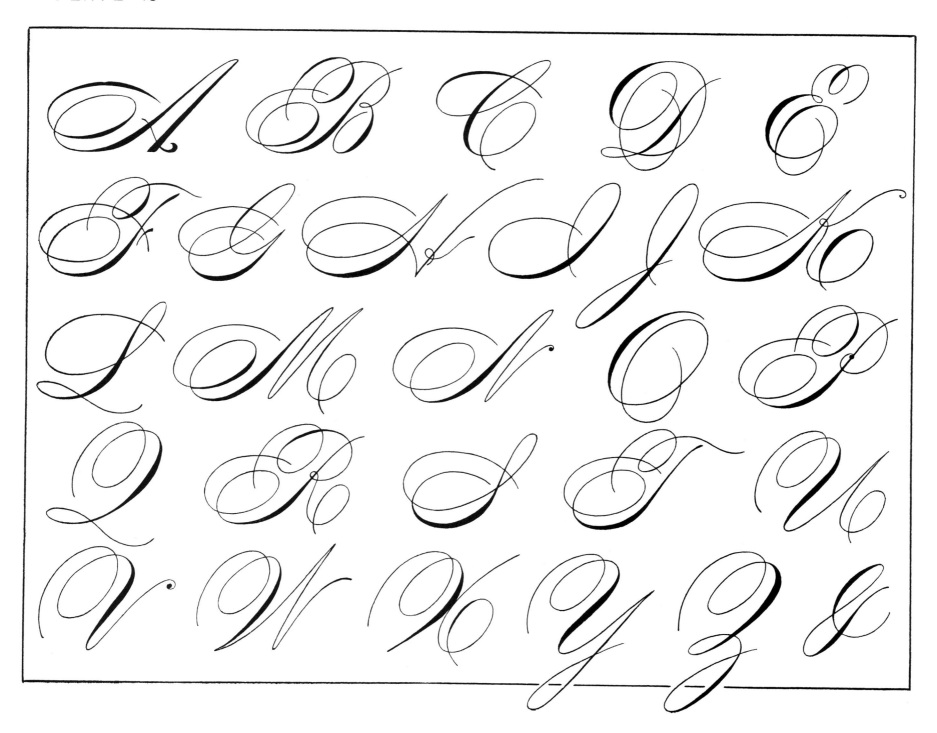

PLATE 44

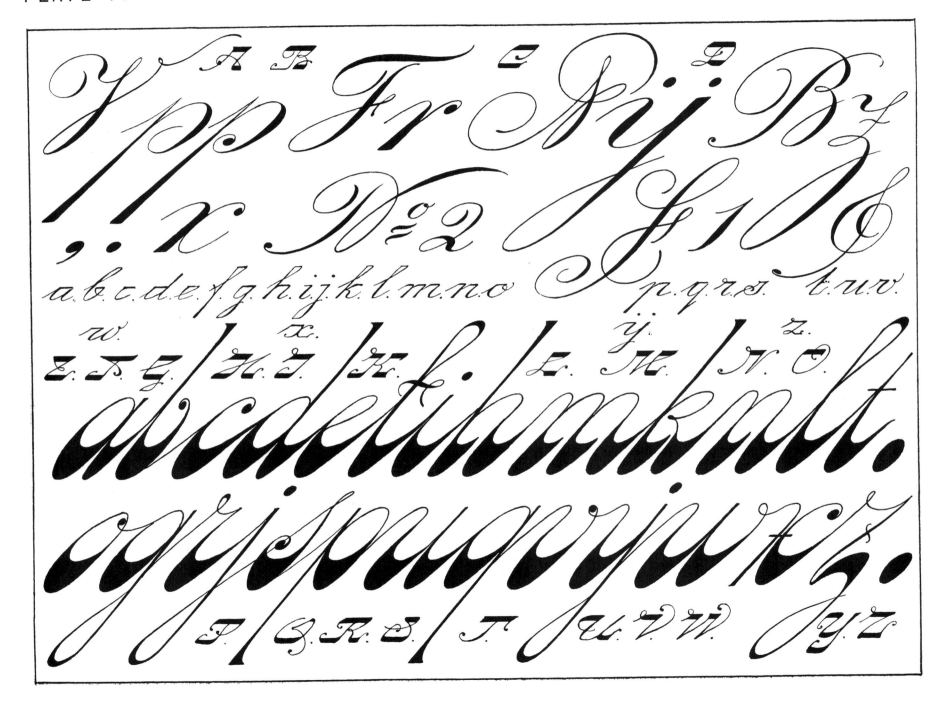

PLATE 45

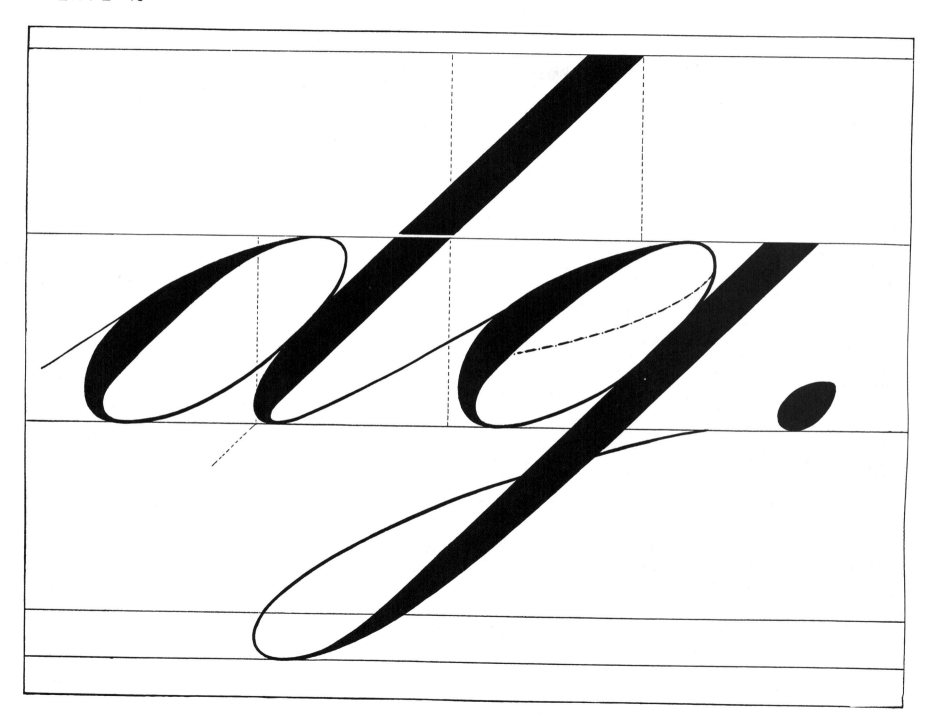

PLATE 46

ABCDEFI
GHJKLMN
OPQRSTU
VXWYZ&

PLATE 47

ADEGJOORT
W & ABCDEGH OR
A EM DO BU. M

a b c d e f h i k l m
n o r s t u v w x y z
g j p q

PLATE 48

A B D E

G J K N R

C F H I L O

P T M V

PLATE 49

A B C D E G H I

J L M N R S W.

F K O P T U Z

V C D H S A N.

VAREBUSTI

DANMFMPRK

PLATE 50

ABCOLEVRDFGH
IKMNPQSTXYYZ 1657

ABCDEFGHZ
IKLMNOOPR
STTUVWXYT
·1700··

AI.LUO.HB.SG

PLATE 51

ABCDEGHIJ
KLMNOPR
STUVWYZ&
ABCDEFGHI
JKLMNOPW
RSTUVXYZ

PLATE 52

ABCDOEHF
GIJKLMNPST
RUYWXIZQ&
Victor Emanueldkh
bf svwxz g1pqy·R
1234567890.

PLATE 53

PLATE 54

BCDEFG
ABIJKLMO
XSNQRPT
UVWYZ fgijpq
abcdehiklmnorsſtup
J2345, vwxz. 678 90

PLATE 55

GOTISCHE e
ABDHZKOMm
LNPRUVWw
XYZabodffcgjph
kqinrsluvxzyt

PLATE 56

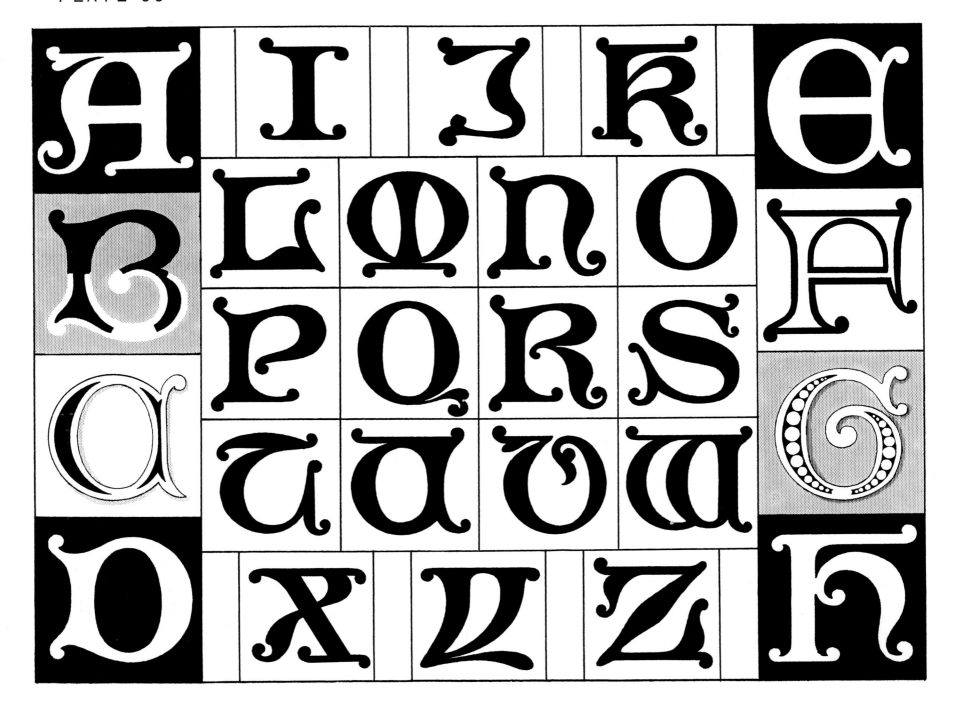

PLATE 57

Series 8: GERMAN LETTERS

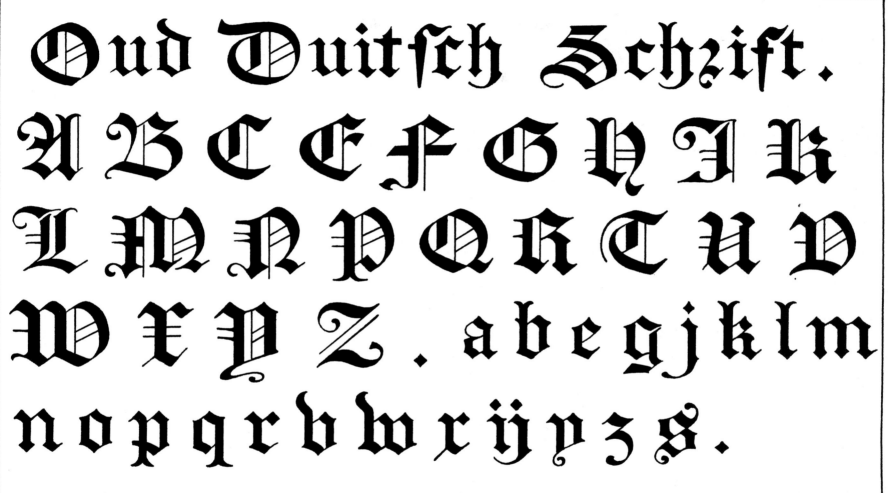

Oud Duitsch Schrift.

A B C E F G H I K
L M N P Q R T U V
W X Y Z . a b e g j k l m
n o p q r b w x ÿ p z s .

PLATE 58

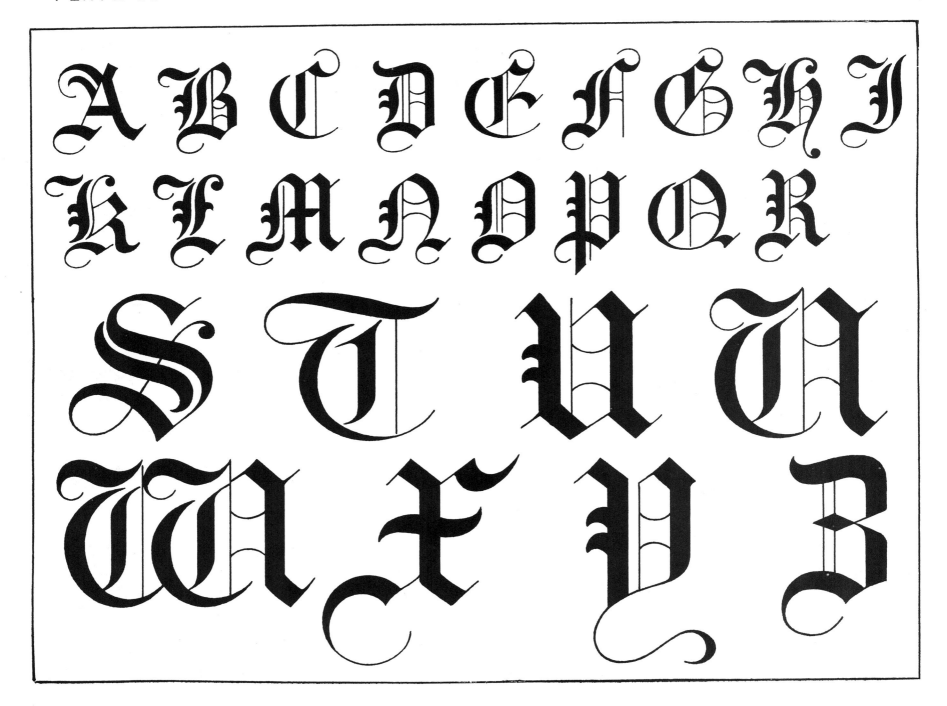

PLATE 59

ABCDEFG
HIKLMN
OPQRST
UVWXYZ

PLATE 60

abcdefghij

klmnopqrs

tuvwrᵞʒ

PLATE 61

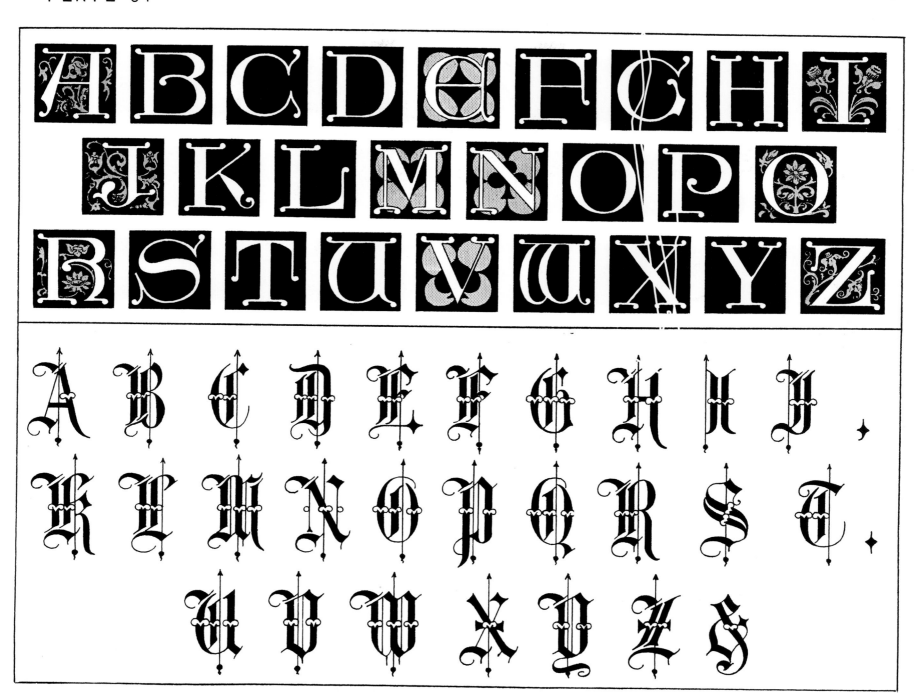

PLATE 62

A A · B · D D · E E · F · G G

H · I I I · J · K K K · L L · M

N N · P P P · R R R R · S S

U U U · X · Y Y · Z Z · Uv

A B C C Ch D Godefr

rynuaknſ ILI yʒv ſ

K ▪▪▪▪▪▪▪▪▪▪▪ S

PLATE 63

D. De Landbouw. w G

ABBCEGEEHHFF

KMNNQPRJSTTUV

VTBVWWWWXOZz

ffhkltcimorsvzs.yqpjg

1234567890

PLATE 64

ABCDEFGHIJ
KLMNQPRST
UVWXYZbdfht
lkaceimnorsuvwz
gjpxy & 1234567890.

PLATE 65

Series 9: ROUND HAND SCRIPT

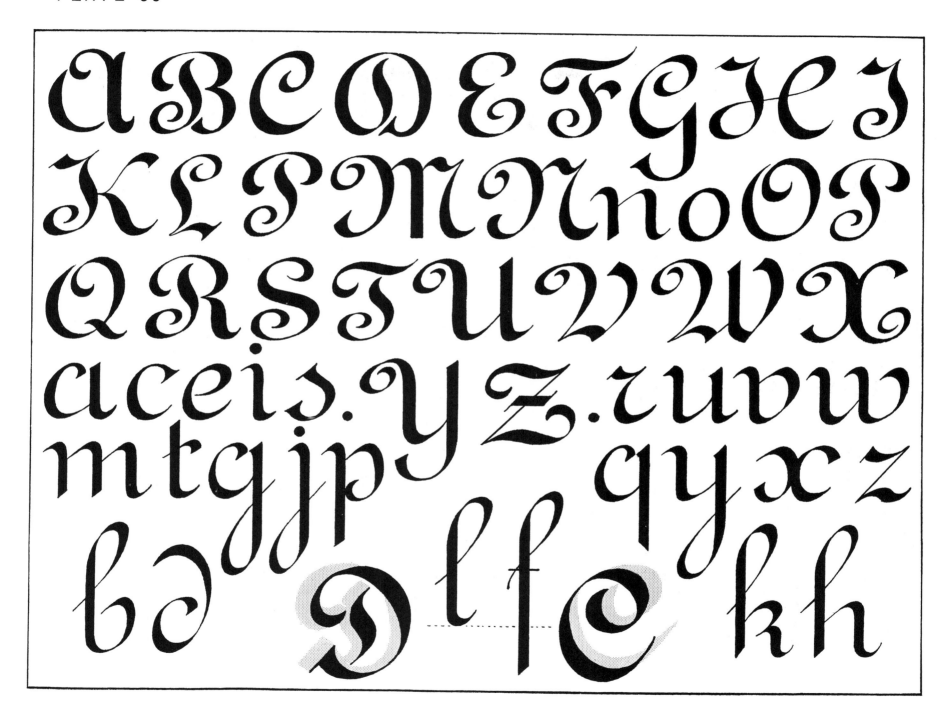

PLATE 66

A B C D E F G H
I J K L M N O P Q
R S T U V W X Y
Z abulonmerisdhktfy
cgjvwxzvwpq.

gemujchjapysz
wdkflub. modern schrift

PLATE 67

Decoratie Schilders.&

bfkmnuvwkz gjpqyz

ABCEFGHIJKLN

MCRPTUYWHZ

abcdehilmostui

PLATE 68

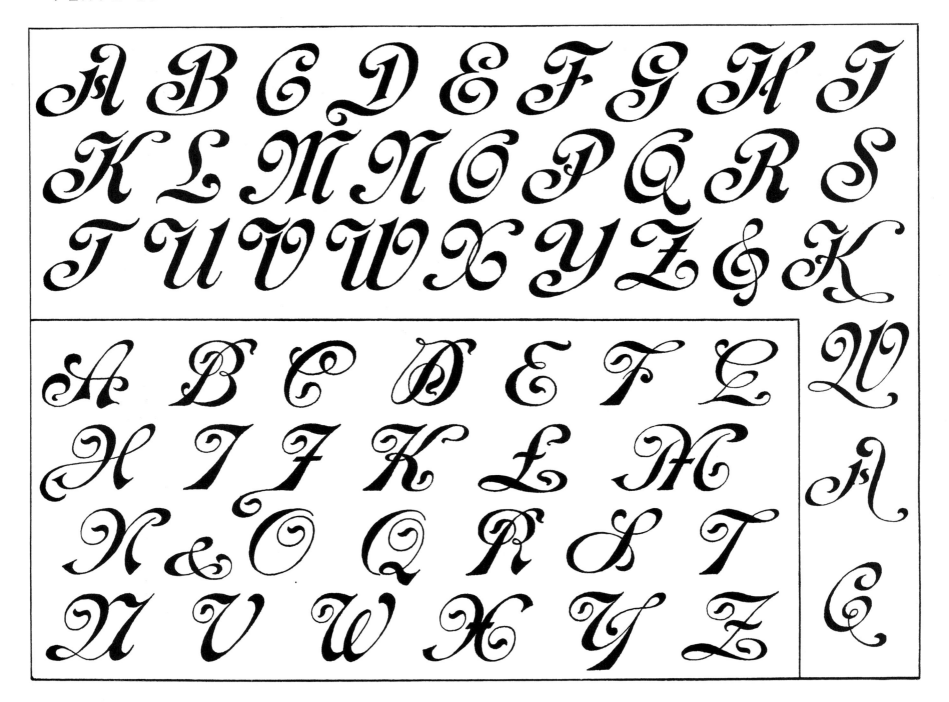

PLATE 69

abcdefghijklmnop
kqsrtuvwxyzßr

abcdefghijklmr
Popqstuvwκyz

PLATE 70

A R C H I P E L S s
U O B D F E K M m
N Q V W X Z J

a c e i n o r u v w x z
b d h k l t . f g p q i j y .
& a e o u s v January

PLATE 71

Modern Schrift.

PLATE 72

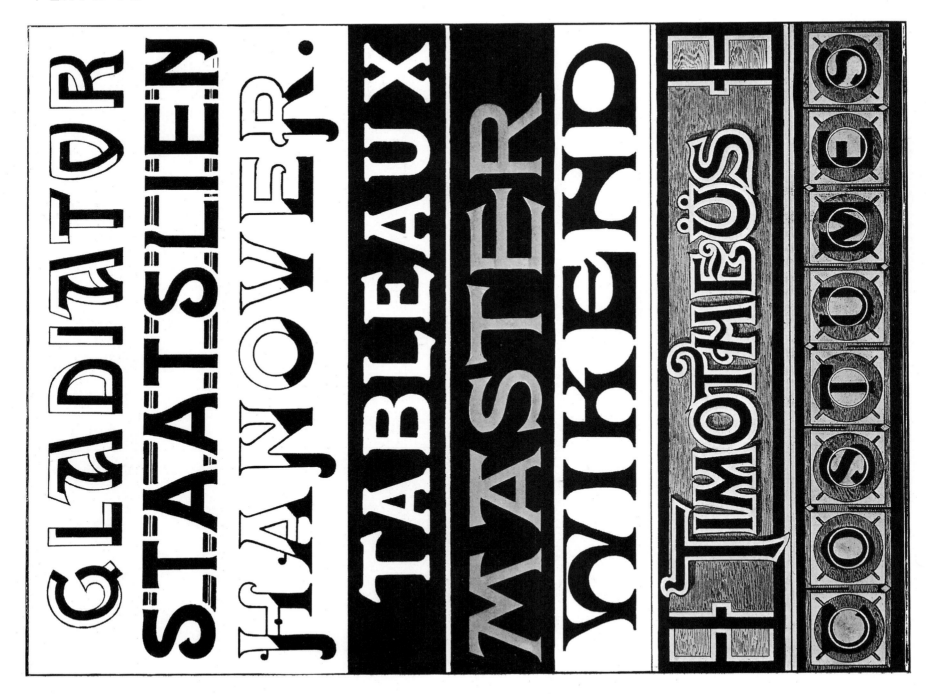

PLATE 73

AUGSBURG

LODEWIJK

NEDERLAND

SOHUKI.

KUNST

GFNPZI

Zak-Apotheek

PLATE 74

TARIEF.

RIETWERK

M K E H

PLATE 75

PLATE 76

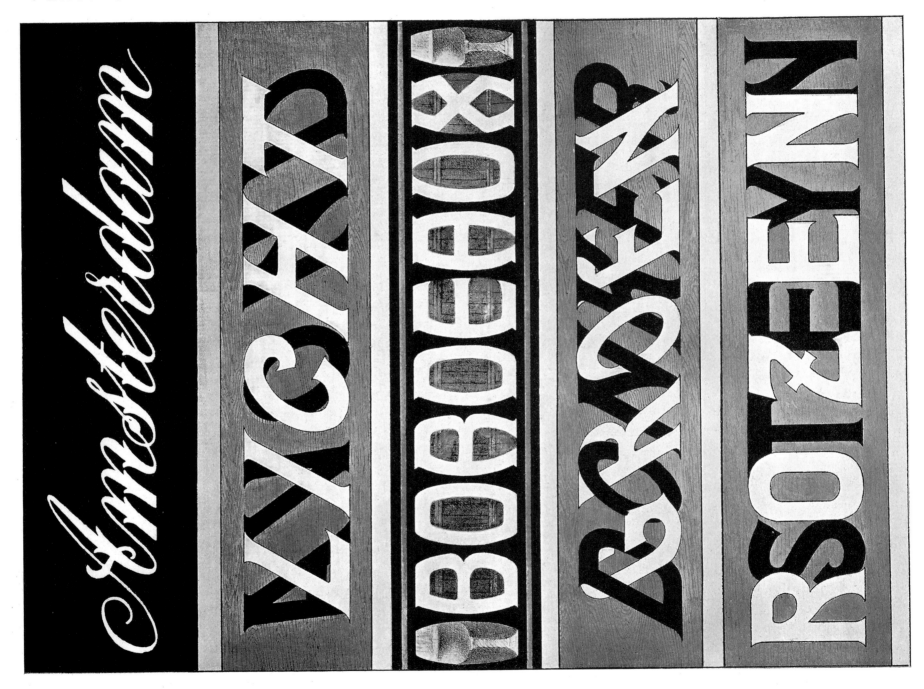

PLATE 77

PLATE 78

ADELONG · 1

SOUVENIR

ARNHEM

FRIESLAND

GORICHEDIK

PLATE 79

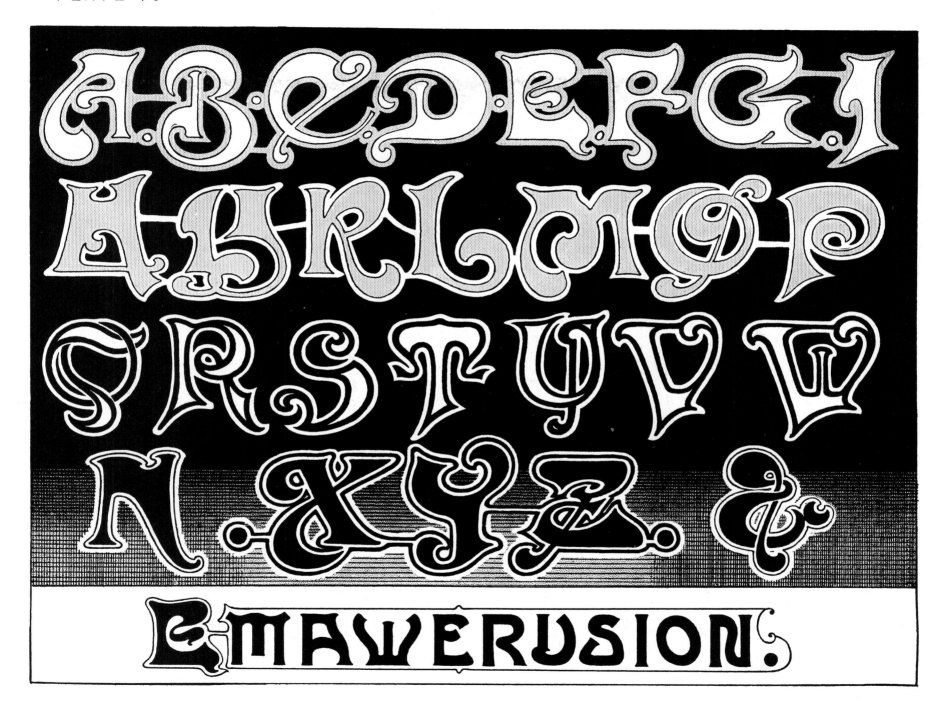

PLATE 80

NIEUWSTAD

DUITSCHLAND

DECORATIE

KUNSTWERK

LACK & TEWS

BEROMINTERNA

H-BURGERSCHL.T

ABDFJKLMNSU

PLATE 81

BALTIMORE
CDFGHJKNP
SUVWXYZ

ACFGHJKMOPETVR
Y·NIEUWSBLAD·Z

OPGERICHT - 1832

PLATE 82

RIJSNOER

HYACINTH

AMETHYST

BERYL

PAREL

CHRYSOPRAS

VICTORIA

VOORSCHOTBANK

AMSTERDAM

VWXYZ·0987654

PLATE 83

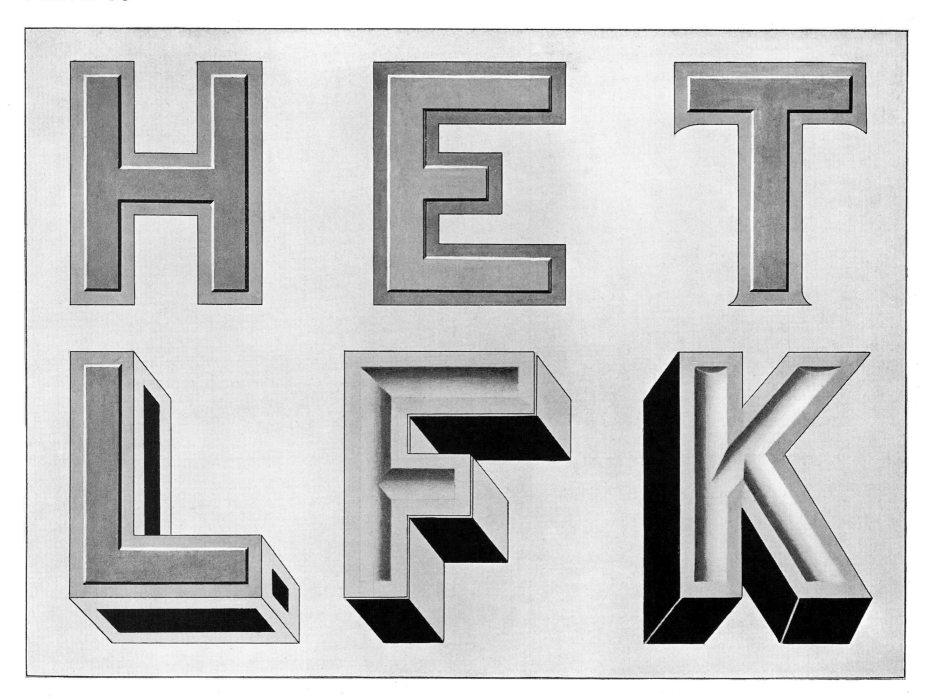

PLATE 84

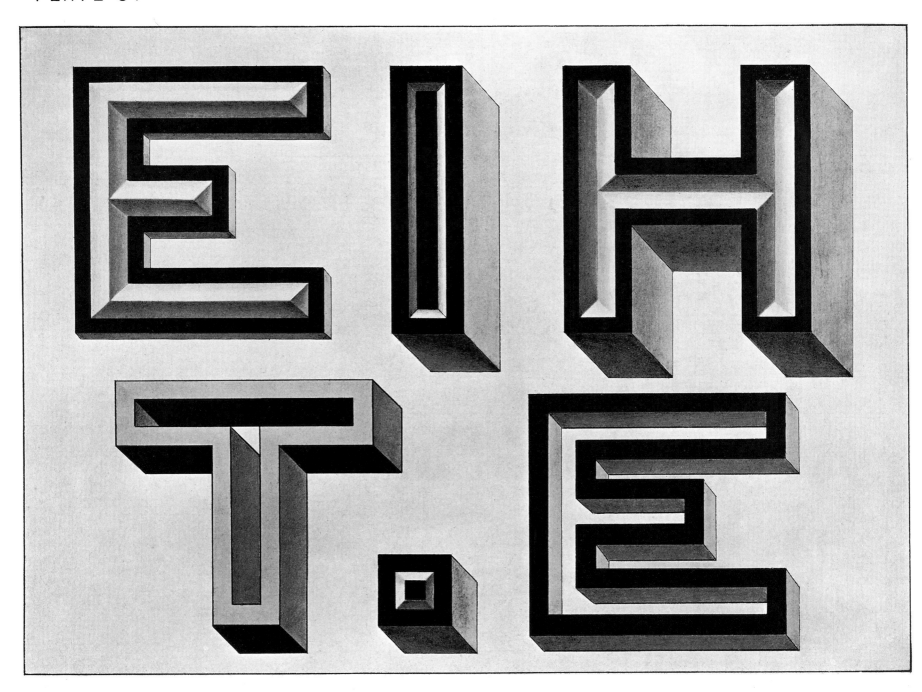

PLATE 85 Series 11: NUMERALS AND FIGURES

1234556789 0

1234567890

1234567890

1200 3450 8679

8912345706 № 3

PLATE 86

123456789·12

34567890

123457-36825-

1237458-23456

87-210357894-12

34567 & 49812375

PLATE 87

PLATE 88

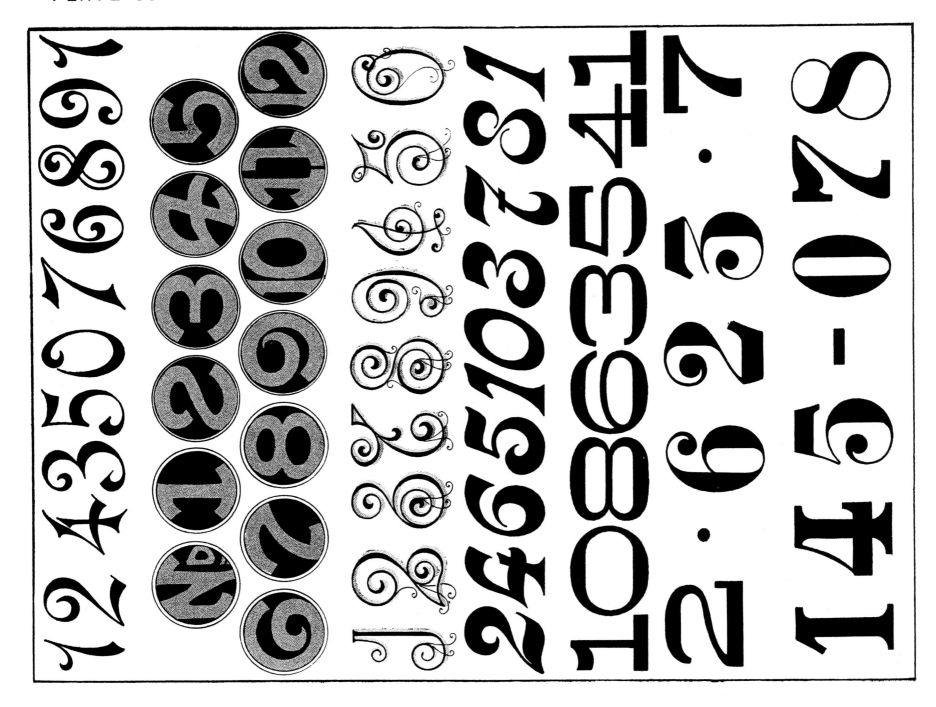

PLATE 89

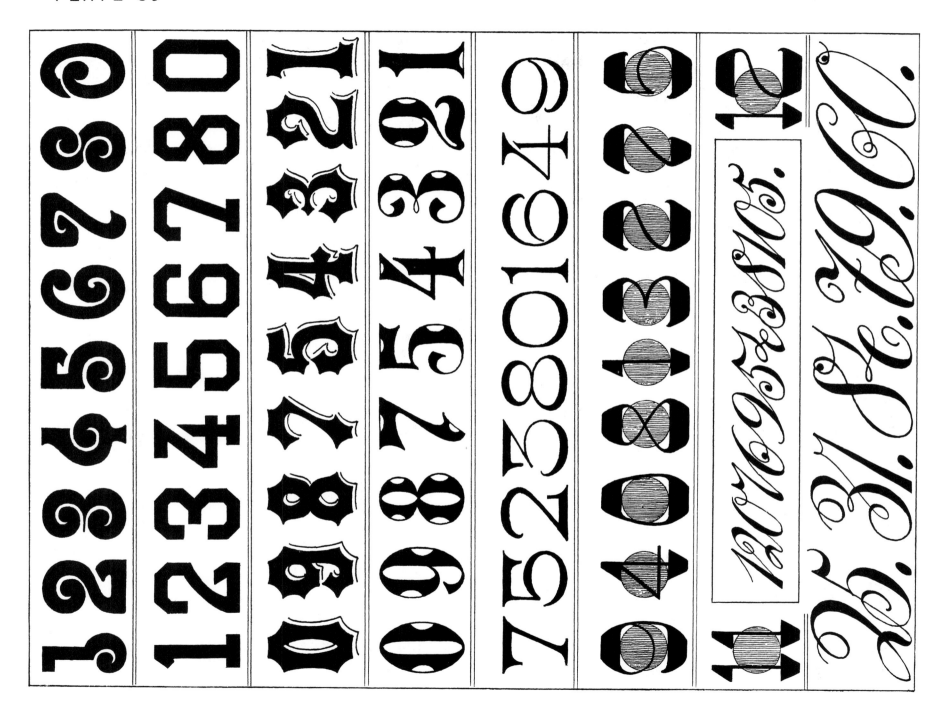

PLATE 90

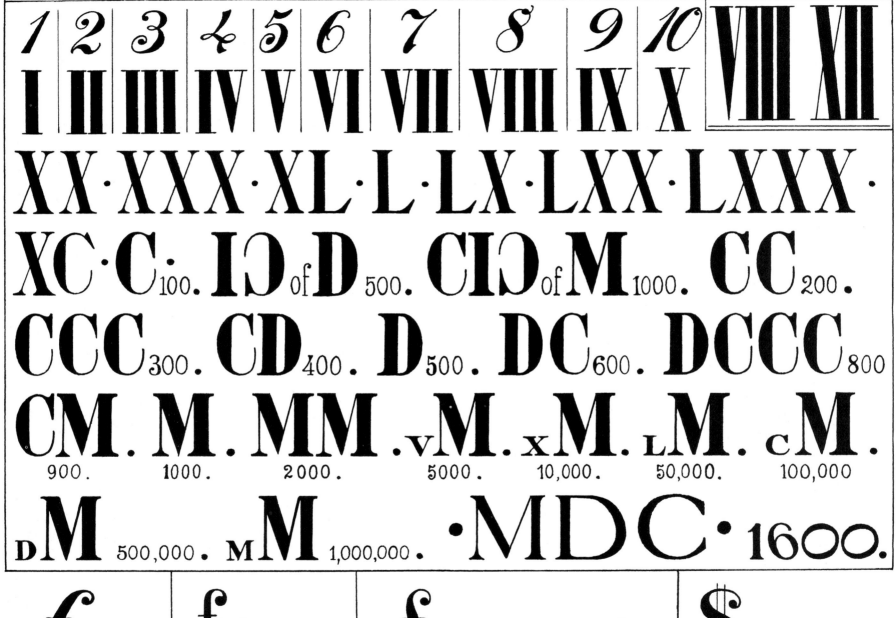

1 2 3 4 5 6 7 8 9 10

I II III IV V VI VII VIII IX X

VIII XII

XX · XXX · XL · L · LX · LXX · LXXX ·

XC · C·₁₀₀. CIↃ of D ₅₀₀. CIↃ of M ₁₀₀₀. CC ₂₀₀.

CCC ₃₀₀. CD ₄₀₀. D ₅₀₀. DC ₆₀₀. DCCC ₈₀₀

CM. M. MM. vM. xM. lM. cM.
900. 1000. 2000. 5000. 10,000. 50,000. 100,000

ᴅM 500,000. ᴍM 1,000,000. · MDC · 1600.

ƒ Gld. | fr. Franc | £ St. pond sterling | $ Dollar.

PLATE 91

ANNO·1705·3826493·1756

1234567890 MCMIV·MDCCCCVI·1565

123456789034

1234567890·12345
38760

1904876523·2232

1234567890·5628·

1234578600900·2345
7800

PLATE 92

Series 12: MODERN AND OTHER
LETTER TYPES

ABCDEFGHI
JKLMNOPQV
RSTUWXYZ
LN Œ & CH EH

WINTER — BLOEM

PLATE 93

MACHINALE INRICHTING

ABCDEFGHI
JKLMNQPWI
RSTUVXYZI

EAST HUDSON

PLATE 94

A

AB CDEFGH DIJKL

MMMMMNHOPPQW

RRRAAABBHGTUI

UUVVVXZZYCSXLO

FABBAADWVAAJCTIS

DECARDUSGERKUNST

PLATE 95

ABCDEFGHIJK
LMNOPORSTUV
MAG OWXYZZ RAW

ABEDCFGHIJKLN
MOPQRSTUVWX
YZ. ANDHWALGBI

PLATE 96

MABLURPAEAMDRRU
DTRGEHAFFEROOCEI
ROMARAEDAR
EBAIRAAVAH
AUDOH VANDISK
SCHFULOSM LEONARDUS

PLATE 97

VIEAKPNQLOS
BCDFHJMRUI
BTGWYZIUTOX
AADOMBURG GO

LBZRPDIetdfhbkaceimnor
suvwxz gjpqy·DADKLXUZAM

PLATE 98

ABCDEFGHIJKLMNO
PQRSTUVW&YXYZ

ABCDEFGHIJK
LMNPQRSTVWY

21603243 - YZ - 634075

ABCDEFGHIJKLMNOP
QRSTUVWXYZ

PLATE 99

AABCDEFGHIJKLMNO
PQRSTUVWXYZ.

ABCDEFGHIJKLMNOPQR
LBTESSTUVWXYZ&&&

ABCDEFGHIJKLN
MOPQRSTUVWXYZ.

PLATE 100

ABCDEFM
GHIJKLN&
OPQRSTU
VWXYZ

PLATE 101

ABCDEFGHIJ

KLMNOPQ J

RSTUVWZYX

B · A R N · B

1236 C9 5 E6

PLATE 102

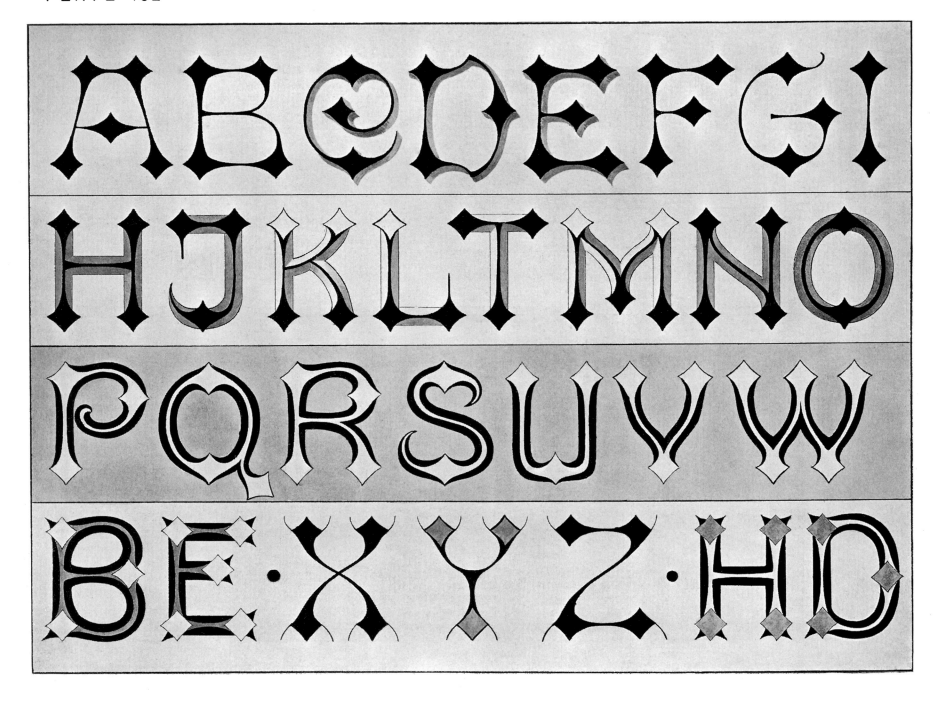

PLATE 103

ZURICHW
PEMOXY
FRANSGJ&
JKVBDLTQ
1234567890.

PLATE 104

ABCDEFGHIJ
KLMNOPRST
UVVWXYZ

AEI OU
BDKWS

PLATE 105

ABCDEGH
IDKLMNW

AVOEPRSTU
A-F-Y-Z-L

PLATE 106

A A B C & D E F G
H I J K L M N W
O P R R R S T N U
D V X Y Z Q . y q p j
Z e s o n g k i h u b d f t l
a a c r v m w x z .

PLATE 107

ABCDE
FGHIKL
MNOPRJ
STUVW
XYZW

PLATE 108

ABCIEȚTVFM
aceimno
rltdhkb
qfgjiyp
suvwxz
PODYRWKS

PLATE 109

ABCDEFGHIJ
KLMNQPRW
STUVXYZ&

ANOMIED
RTCKBLJ
PHZYUG.

PLATE 110

ABCDEFGHIJKLM
NORPSTUVVWXYZ.
Aabchdefiklmnors M
schuwvzt·vun gijovaa.

12008 & 97.543

ZŒEOC & LCWU

PLATE 111

ABCDEFGHIZ
KLMNOPRST
UVW GGGG XYZ

abcdefhikl
mnorstuvwz
gipqy

PLATE 112

ABCDEFGHIJKLM
NOIPRSTUVWX
Yabedcfihmnkloutrsvw
gjpqxyz.12508&4637.

PLATE 113

HARLIGEMOOTUSKW.

HULODATESRKGVJNZC&Y

dfhkltacenorsvxzĝĜJPY. WAO.

HGNWAM. HOSNKA. NESI

DV B. HEB. HERVSG.

LVJFAYRWZSMGI

ABCDEGHJKSNOP

LZVRX. NPEZAJ

PLATE 114

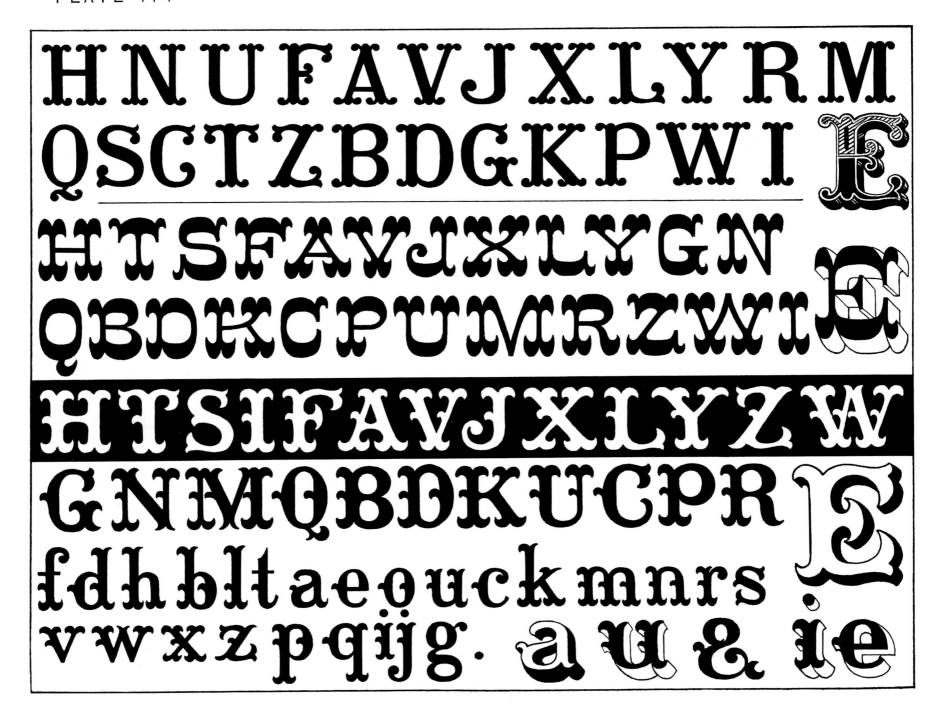

PLATE 115

Haeioudfhkltcnrsv YGJP.

HFJLYAVOTZNBRPSI
KDXCWQGMEU

ABCDEFGHIKLY
MNJOPRSTUW
QXYZ& aeioucnrvgjpy
·sxzbdfkhl 1420.t

PLATE 116

FAVZLTJHKDERSG

MWBCINOPQUXY.&

IEOB IBAT VATU.

ABCDEFSHIKLM

NQPRSTVWXYZ

aceimnr bdfghjklpt.UJ.&
osuvwxz

PLATE 117

ABCDEFGHIJKLM
NOPQRSTUVWXZ
bdfhklta eouigjpq
cmnrsvwxz

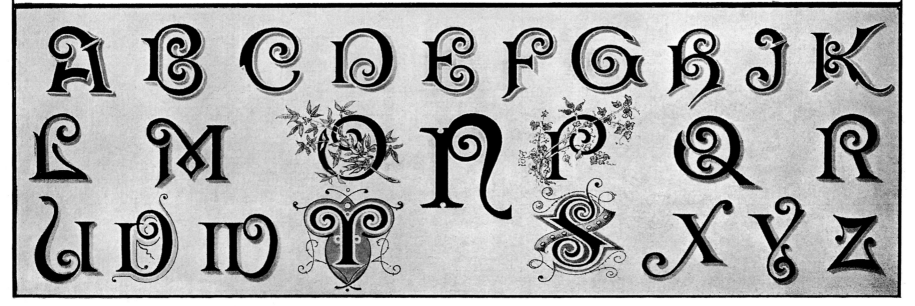

PLATE 118

ADSSMNNPKSVI

XZLFIREBC

TOQUWXY

abcdefgijklmnopqr

stuvwxyzh

PLATE 119

A B C D E F S H I
J K L M N G P Q R
S T U V W X Y Z.

A B H P B K R Heldrina
bcfghj- kmopstuvwxyz.

PLATE 120

Kunstschilder. DZSℒOW

ℐℒCℐRVℋℲ awokzbmx

ABEFGℋℌℐℐMNPUℬ

𝐌. fgijpqvyℏ 𝐍.

1234567890l

PLATE 121

ABCDEFGHIJK
LMNOPRSTV
UWZQY.aeiouc
mbvdnfffrhsklw
gjp xtz qy&

PLATE 122

A B C D E F G H
I J K L M N O W
P Q R S T
U V X Y Z

PLATE 123 Series 13: FOREIGN AND OTHER LETTERS

Duitsch Alphabet Drukschrift.

A B C D E F G H
I J K L M N O P
Q R S T U V W X
a b c d Y Z e f g h i j
f l m n o p q r s f t u v
ch ck . w r y z . h ß

PLATE 124

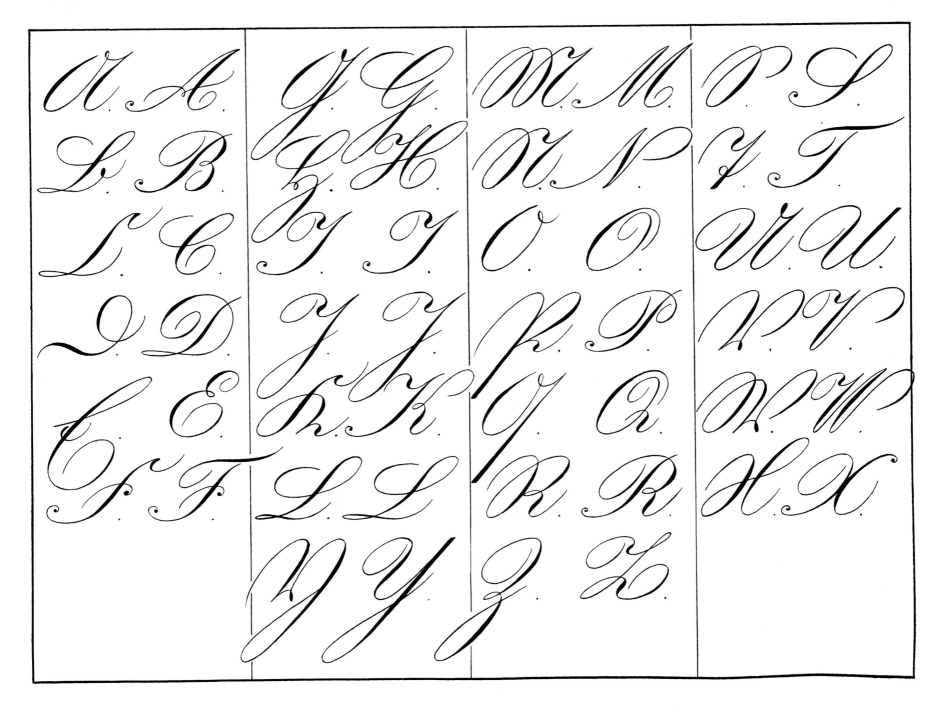

PLATE 125

Kleine

Umlautende Vocale

Zusammengesetzte Vocale
(Diphthongen)

Zusammengesetzte Consonanten

PLATE 126

A _ a. _ a	Ж _ ž. _ ж	M _ m. _ м	T _ t. _ т	Ш _ š. _ ш	Э _ e. _ э
Б _ b. _ б	З _ z. _ з	Н _ n. _ н	У _ u. _ у	Щ _ štš. _ щ	Ю _ yu. _ ю
В _ v. _ в	И _ yi. _ ий	О _ o. _ о	Ф _ f. ph. _ ф	Ъ _ Erhärtung. _ ъ	Я _ ya. _ я
Г _ g. _ г	I _ i. _ i	П _ p. _ п	Х _ x. _ х	Ы _ ÿ. _ ы	Θ _ f. _ o
Д _ d. _ д	К _ k. _ к	Р _ r. _ р	Ц _ ts. _ ц	Ь _ Erweichung. _ ь	V _ ü (v). _ v
Е _ ye. _ е	Л _ l. _ л	С _ s. _ с	Ч _ tš. _ ч	Ѣ _ ê. _ ѣ	

PLATE 127

А а (a.)	*Ж ж* (ž.)	*М м* (m.)	*Т т* (t.)	*Ш ш* (š.)	*Э э* (e.)
Б б (b.)	*З з* (z.)	*Н н* (n.)	*У у* (u.)	*Щ щ* (šts)	*Ю ю* (yu)
В в (v.)	*И и* (yi)	*О о* (o.)	*Ф ф* (f. ph.)	*Ъ ъ* (Erhärtung)	*Я я* (ya)
Г г (g.)	*І і* (i)	*П п* (p.)	*Х х* (x.)	*Ы ы* (i)	*Ѳ ѳ* (f.)
Д д (d.)	*К к* (k.)	*Р р* (r.)	*Ц ц* (ts.)	*Ь ь* (Erweichung)	*Ѵ ѵ* (ü (v.))
Е е (ye.)	*Л л* (l.)	*С с* (s.)	*Ч ч* (tš)	*Ѣ ѣ* (ě)	*v* (v)

PLATE 128

ABCDEF
GHIKLM
NOPQRS
TVXYZ

PLATE 129

Grieksch Alphabeth.

A	α	alpha	a.	I	ι	iŏta	ij	P	ϱ	ro	r.
B	β	bēta	b.	K	\varkappa	kappa	k	Σ	σ	sigma	s
Γ	γ	gamma	g.	Λ	λ	lam(b)da	l.	T	τ	tau	t.
Δ	δ	delta	d.	M	μ	mu	m	Y	υ	u.	u.
E	ε	ẹ	e.	N	ν	nu	n.	Φ	φ	phi	ph.
Z	ζ	zdĕta	z.	Ξ	ξ	xi	x.	X	χ	chí	ch.
H	η	èta	è	O	o	ŏ	o	Ψ	ψ	psi	ps
Θ	ϑ	thēta	th.	Π	π	pi	p.	Ω	ω	ŏ	ŏ.

PLATE 130

A	a	H	n	N	v	T	l
a.	alpha	i	ita	n.	ni	t.	taf.
B	b	V	V	Z	ʒ	V	v
w.	wita.	o	thita	ks.	ksi	i.	ipsilon
T	γ	T	ι	O	o	Φ	φ
g. δ.	gamma.	i	jota	o.	omikron.	f.	fi
D	δ	K	u	Π	ϖ	X	x
δ.	delta.	k. k'	kappa	p.	pi	x. x́	hhi.
E	ε	Λ	M	P	ρ	Ψ	ψ
ε.	epsilon.	l.	lamwda	r.	ro.	ps.	psi
Z	ʒ	M	μ	Σ	σ	W	ω
z. ź.	zita.	m.	mi	s. ś.	sigma.	o.	omega.

PLATE 131

Hebreewsch Alphabeth.

1.	ʾāleph ʾ	9.	ṭēth t.	16.	ʿajin ʿ		
2.	bēth b bh.	10.	jōd j.	17.	pē p. ph.		
3.	gīmel g gh.	11.	kāph k.	18.	ṣādē ṣ.		
4.	dāleth d. dh.	12.	lāmed l.	19.	qōph. k		
5.	hē h.	13.	mēm m.	20.	rēš r.		
6.	wāw w.	14.	nūn. n.	21.	sīn s.		
7.	zájin z.	15.	sāmech s.	22.	šīn š		
8.	chēth ch.			23.	tāw t th.		

PLATE 132

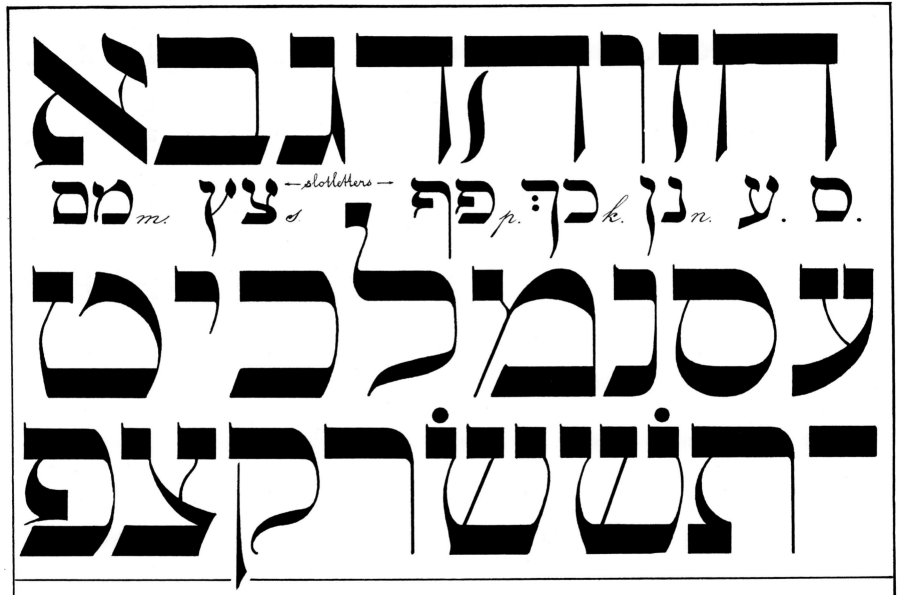

PLATE 133

A a	a	
B b	b.	
C c	g	
D ꝺ	d.	
Є e	e.	
F ꝼ	f.	
Ꝑ ȝ	g.	
ħ h	h.	
I 1	i	

k k	k.	
L l	l.	
Ɯ m	m.	
N n	n.	
O o	o.	
P p	p	
R ꞃ	r.	
S ꞅ f	s.	
T ꞇ	t.	
U u	u	

V p	w.	
X x	ks.	
Y y Ẏ ẏ	ii	
Z ꝫ	dz.	
Ð ð	ð	
Þ þ	o.	
ꓶ ᛁ	and.	
Ꝥ	pæt.	
Ɨ	adde	

a a	a	
ð b	b.	
C c	k.	
ꝺ ꝺ	d.	
Є e	e.	
F ꝼ	f.	
ꝝ ꝝ	g.	
l l	i	
ʒ l	l.	

m m	m.	
N n	n.	
O o	o.	
ꝓ ꝓ	p.	
Ꞃ ꞃ	r.	
S ꞅ	s.	
T ꞇ	t.	
U u	u.	
h h	h.	

PLATE 134

Letters	Value		Letters	Value
A A	a.		M	m.
B	b.		N	n.
Λ Λ	g.		O	o. u.
D Δ	d.		Γ	p.
⸠ ⸠	e, ei.		Q	q.
⫶	dz.		P R	r.
⊞	e. h.		⚡	s.
⊕	th.		T V	t.
⊙ I	i.		V	ü.
K	k.		Φ Φ	ph.
V L	l.		X +	kh.

Letters	Value		Letters	Value
A	a.		Ϭ	r.
B	b.		Π	u.
Γ	g.		Π	p.
d	d.		Ψ	r.
ε	e.		R	s.
u	g.		S	t.
Z	z.		T	v.
h	h.		Y	f.
Φ	d.		K	ks.
I	i.		X	w.
κ	k.		Θ	o.
λ	l.		↑	
m	m.			
H	n.			

Letters	Value		Letters	Value
A Λ Λ Λ	a.		M M	m.
B	b.		N N	n.
C	c.		O	o.
D	d.		Γ	p.
E ‖	e.		Q	q.
F Γ	f.		R R	r.
Z	z.		S	s.
H	h.		T	t.
I	i.		V	v.
K	k.		X	x.
V L	l.			

PLATE 135

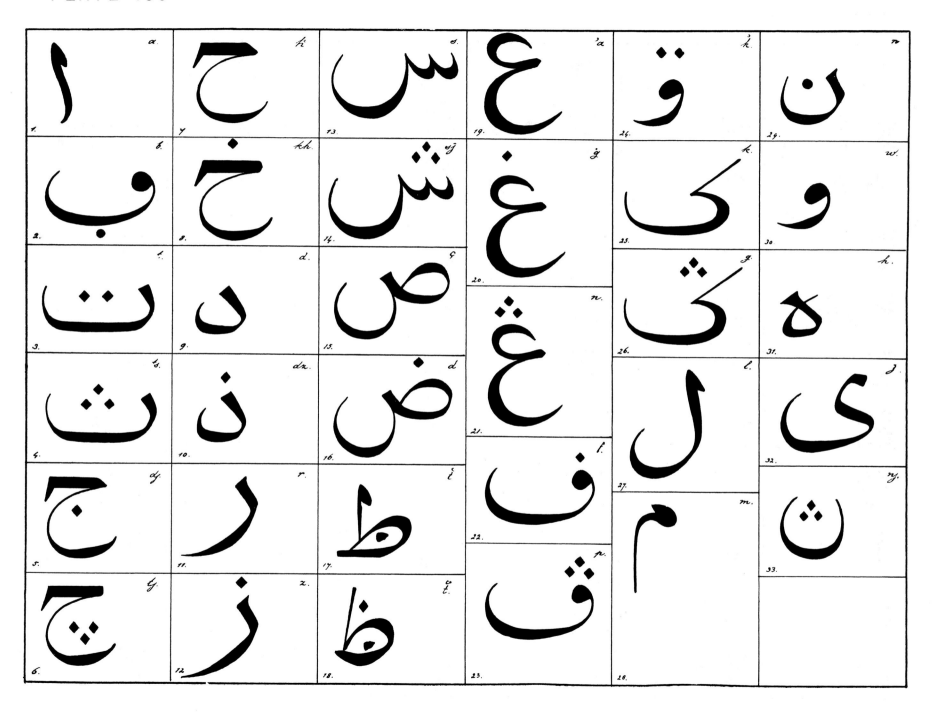

PLATE 136

a.	*z.*	*m.*	*q.*	*n.*
b.	*x.*	*n.*	*r.*	*t.*
g.	*t.*	*s.*	*ṣ.*	*l.*
d.	*y.*	*s*	*t*	*r*
h.	*k.*	*ph.*	*n.*	*ṣ.*
w.	*l.*	*s.*	*ṅ.*	*r*

PLATE 137

Series 14: MONOGRAMS, VIGNETTES AND HANDS

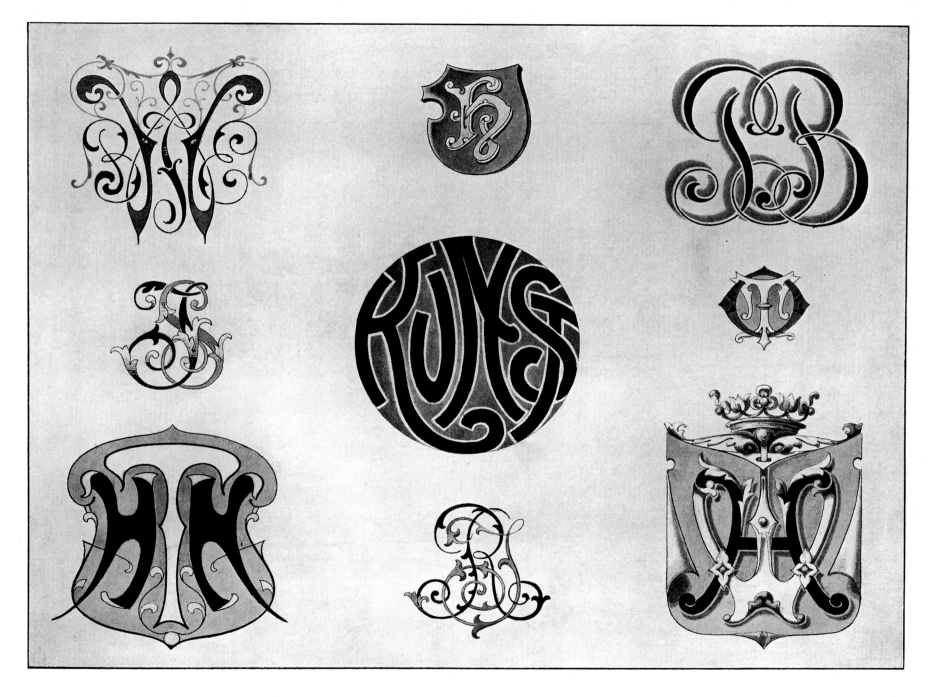

PLATE 138

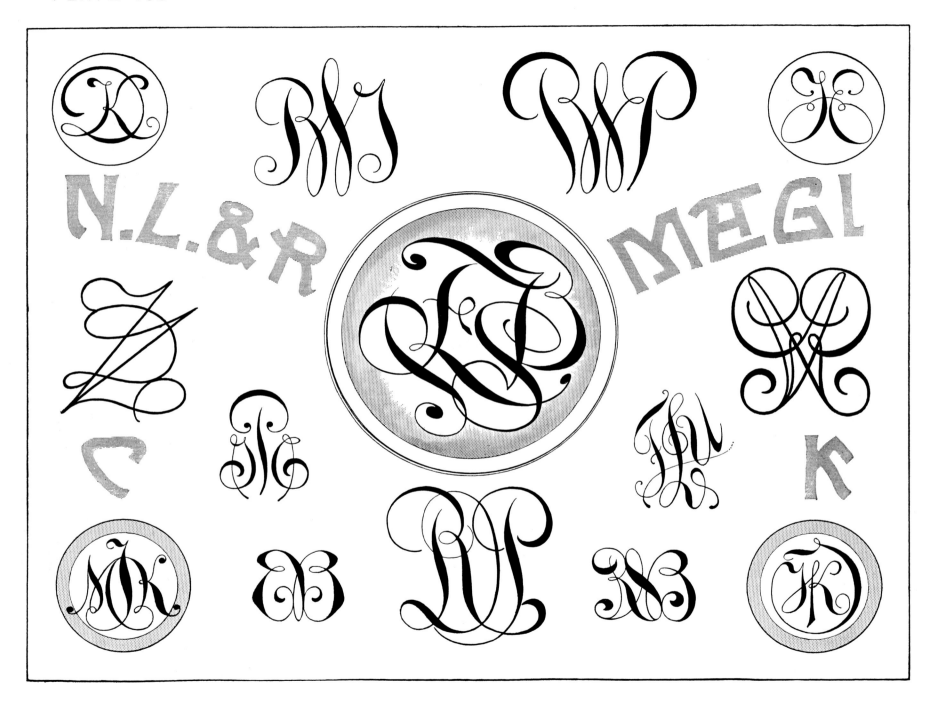

PLATE 139

PLATE 140

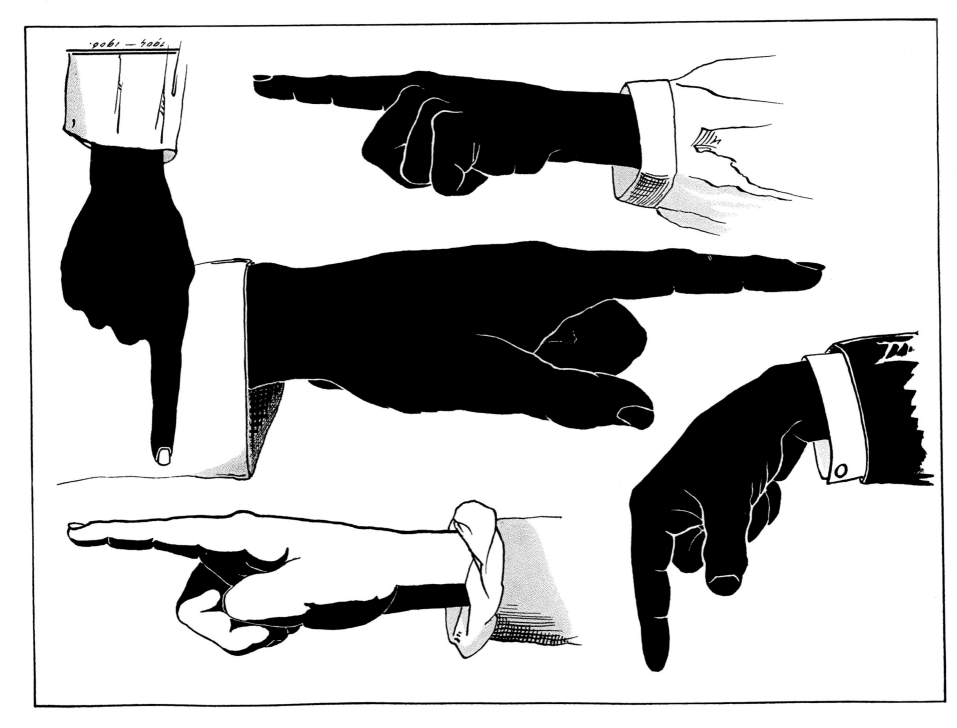